JAN 2009 W9-AAT-128

AUBURN

IMAGES
of America

FOLSOM PRISON

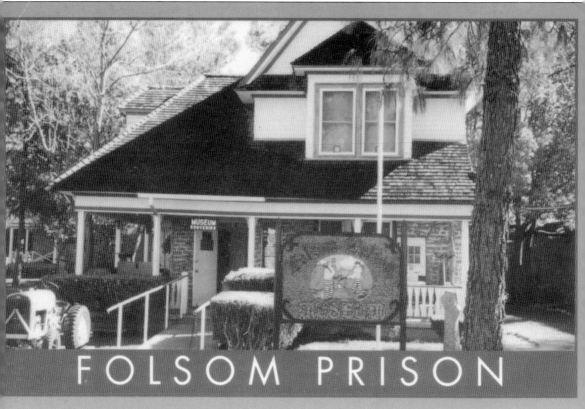

FOLSOM PRISON

In 1975, the Folsom Prison Museum was opened as part of the original prison gift shop, which was operated by inmates. After some of the prison artifacts on display were removed by inmates, the decision was made by retired correctional sergeant John Fratis with the help of California Correctional Peace Officers Association (CCPOA) in 1994 to sponsor the Retired Correctional Peace Officers Museum at Folsom State Prison. The museum is staffed by volunteer docents and is a nonprofit charitable organization, not an entity of the state. The museum is dedicated to the prison staff who have died from cancer. The museum is open daily from 10:00 a.m. to 4:00 p.m. For more information, call 916-985-2561, extension 4589.

IMAGES
of America

FOLSOM PRISON

Jim Brown

ARCADIA
PUBLISHING

Copyright © 2008 by Jim Brown
ISBN 978-0-7385-5921-6

Published by Arcadia Publishing
Charleston SC, Chicago IL, Portsmouth NH, San Francisco CA

Printed in the United States of America

Library of Congress Catalog Card Number: 2008926394

For all general information contact Arcadia Publishing at:
Telephone 843-853-2070
Fax 843-853-0044
E-mail sales@arcadiapublishing.com
For customer service and orders:
Toll-Free 1-888-313-2665

Visit us on the Internet at www.arcadiapublishing.com

This book is dedicated to "Those Who Gave Their All," those correctional officers and staff who made the ultimate sacrifice to keep California safe.

CONTENTS

ACKNOWLEDGMENTS

I would like to thank the dedicated staff of Folsom Prison and all of the California Department of Corrections for their hard work and the Folsom Prison Museum for providing the historic photographs used in this book. Unless otherwise noted, all images are from the museum's archives.

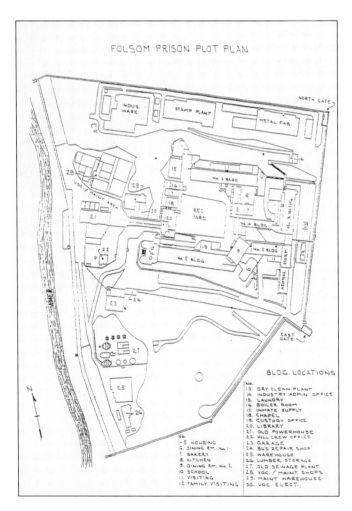

In Folsom Prison's plot plan, one can see the reason there were only three granite walls erected around the prison. The river acted as the fourth wall and had a doubled chain-link fence topped with rolled barbed wire, which now has been replaced with razor wire. There were seven armed towers on the walls and two armed towers on the river's edge, for a total of nine towers. There have been a few changes in locations because of the needs and the growth of the prison since this plot map was done in the 1970s.

INTRODUCTION

The story of Folsom State Prison began on a gray rainy afternoon. As the heavens wept, George C. Perkins, the governor of California, turned the first shovelful of dirt at the ground-breaking ceremony on October 17, 1878, in the area where Building Five is now located.

On July 26, 1880, the prison was formally opened to receive prisoners from San Quentin State Prison. The true history of Folsom State Prison, however, belongs to the men and women who have spent their careers working inside her gray granite walls, providing protection for the citizens of California by ensuring that inmates remain incarcerated in a manner that is safe for staff and imposed by the courts; providing a service to the State of California in a humane, positive, and economical manner; providing work, academic education, vocational training, and specialized training for the inmate population; and continually exploring ideas that can enhance protection for the public while becoming more effective. For the staff at Folsom State Prison, these have been proud traditions for over 125 years of service.

Folsom State Prison and her gray walls have known sweat and occasionally blood. She has no time for those whose lives are about pretense or posturing. She regularly tests the depths of the staff's patience, flexibility, and integrity.

From 1907 through 1910, the East Gate was constructed and the granite "shield," with the letters FSP (with a backward "P"), was chiseled into the granite stone above the walkthrough gate. The shield is the symbol of the prison for justice, courage, and pride.

For those staff who gave the greatest sacrifice of all—their lives—there is a huge granite stone in front of Larkin Hall, named after warden C. A. Larkin, who was killed in September 1937. On this stone are brass plaques containing the names of each employee who died in the line of duty at the prison.

The number one commodity at Folsom State Prison is the staff. Everyone, staff and inmate alike, deserves to be treated with respect and dignity. The mission is not an easy one, and as the old prison (and its recent counterpart just down the road, New Folsom) soldiers into a new age, their work is never truly done.

One

BREAKIN' ROCKS IN THE HOT SUN

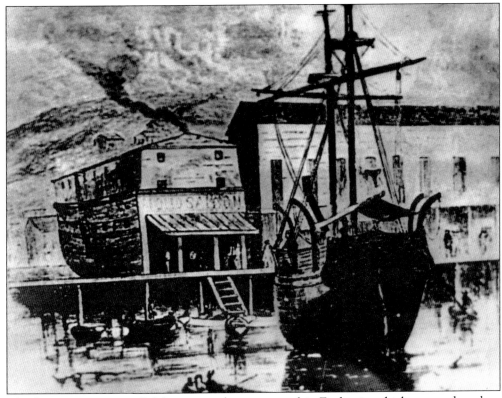

The first state prison in California was the two-mast ship *Euphemia*, which was anchored on the bay near Vallejo. The ship was towed to a site under the shoulder of Point San Quentin in the San Francisco Bay. The first prisoners were received on December 4, 1851, from surrounding county jails. They were immediately set to work turning the ship into a prison capable of holding 50 men. There is no record of the disposition of the prison ship.

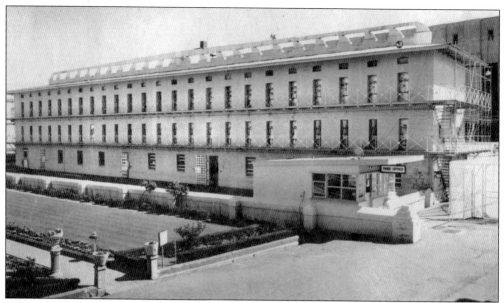

This cell block at San Quentin was called for many years the "Spanish Block" or "The Stones." It had three tiers of cells, the first two built of stone and the third of brick. On ground level, there was a long dormitory room capable of housing 100 men. The cell block was completed in 1854 and remained in use for over a century until it was demolished in the late 1950s.

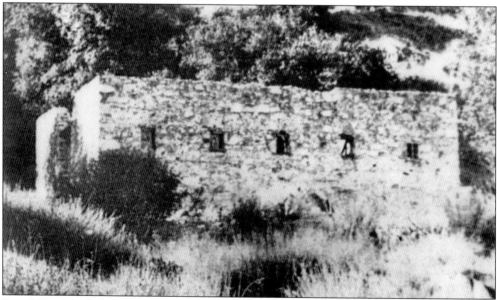

David Smith built the first grain mill in 1851 on the west side of the American River across from the present-day Folsom Prison. In 1854, Edward Stockton from Sacramento purchased half of the mill. He enlarged the mill operation and was prospering until the winter floodwaters of 1861 and 1862 came. The mill was damaged in December and completely destroyed in January by the raging water. Stockton rebuilt the mill, but on January 26, 1867, a fire started. City firefighters tried to put out the blaze, but because of the raging floodwaters, they were forced to retreat back to the city. The mill was completely destroyed; the burned-out rock and wood structure of the Stockton Mill was left to sit abandoned for years.

There were gray, gray skies and gray granite. According to the history of the day, even the heavens wept on the afternoon of October 17, 1878, as the frock-coated group of dignitaries huddled in a semicircle on a bluff overlooking the American River, undoubtedly drawing their velvet collars high about their wet necks. On that afternoon, George C. Perkins, governor of the sovereign State of California, turned the first shovelful of dirt that began the building of the State Prison at Folsom, one of the nation's first maximum-security prisons. It is believed the ground-breaking ceremony took place on this small hill overlooking the river.

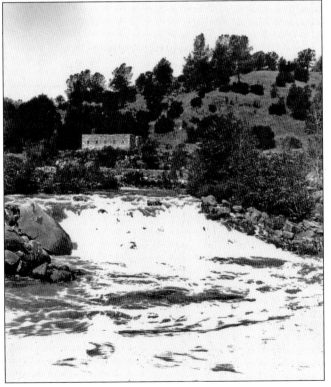

History has it that the old Stockton Mill ruins were used to house the prisoners from San Quentin, after they put up a wooden roof across the old rock walls, to serve as a shelter. Early each morning, the prisoners would cross the river, start clearing the forests near the prison site, and begin building the roads and sewers for the new prison. They cleared a road from the city of Folsom to the prison site, and the prisoners worked the grounds off and on for the next five years until 1878.

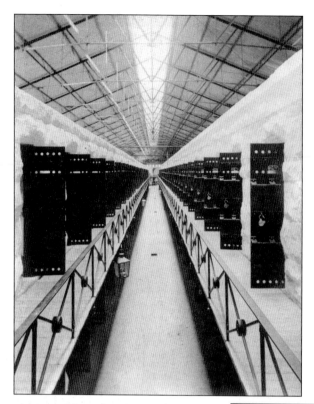

The first two cell blocks consisting of 328 cells were built on a bluff overlooking a bend on the American River. "B" Block was the first finished, with 162 cells, and "A" Block completed with 166 cells. In those days, it was truly a wilderness—rocky hills and jutting granite formations on every side—but the original board had chosen the spot with an eye toward the future. On March 2, 1880, the two cell blocks were completed and a roof built over them. To say they were well built is an understatement—both still stand today.

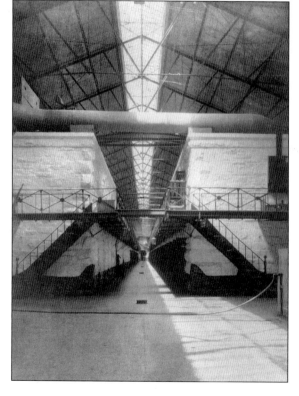

The blocks were built of native stone; here the foresight of the board is obvious. Granite was plentiful, easily quarried, and could be used on the spot. Each block was a unit in itself. To gain a complete picture, one has only to imagine a child with a set of building blocks and the urge to build a "long house." The buildings throughout were of solid stones, tremendous slabs of granite laid one on the other, with mortar between. As the blocks were two cells high and as granite was too cumbersome to be used as the layer between, sheet iron was substituted. This constituted the only foreign building material in the construction of the blocks.

The cells were equipped with heavy iron doors, solid except for a slit 10 by 3 inches, which served for ventilation and inspection purposes. There were no plumbing facilities, and under the circumstances none could be expected. No lights were installed at this time; records do not disclose any manner of illumination. Such was the hurry that the contractors built the original structures with no provisions for a water system. This proved to be one of the first serious situations faced by the new officials.

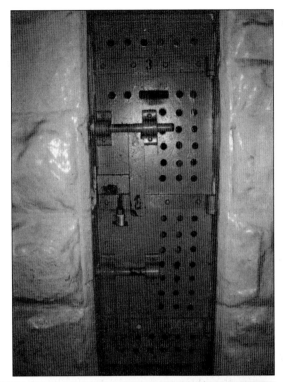

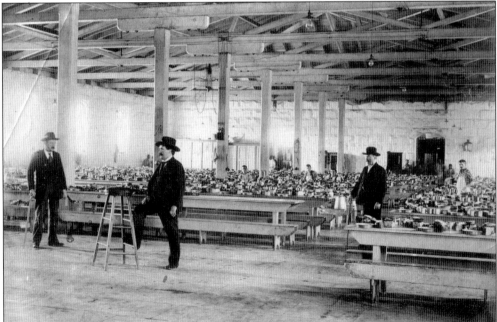

A kitchen (in the area of the present-day kitchen) and dining room (in the area of Unit IV) were constructed. Guards armed with lead-tipped canes presided over this old mess hall. Prisoners served as cooks and waiters. They would shout, "Watch your back," moving among the tables offering prisoners a choice of "tops," the juice of the beans, or "bottoms," which were the beans served from the bean bucket. This photograph was taken in 1894.

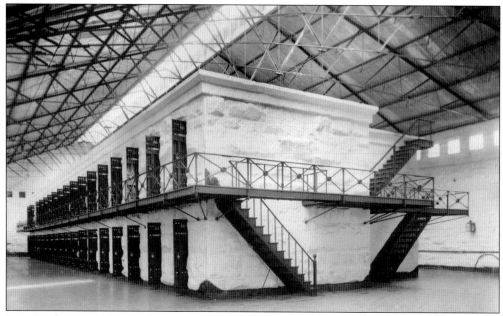

Because the population was increasing rapidly, the board of directors authorized the construction of a third cell block in April 1891. The original 328 cells were built to accommodate two men in each cell, but the count had climbed to almost 700 men, which caused crowded conditions. The new cell block was called "C" Block and was wired for electric lights. The cell block had a total of 70 cells. Now this area today is Dining Room Two. This photograph was taken in 1895.

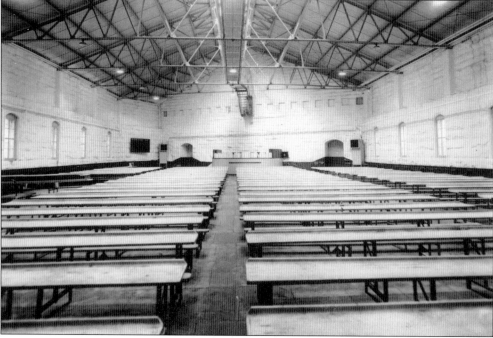

The old dining room is shown here in 1917 with a new makeover—the walls and roof were raised in order to allow a gun walk overhead in the center of the dining room. This was done so during meal time, a guard armed with a rifle could be watching everything below.

A stone tower was built in front of the Administration Building, called the Bell Tower, and was to serve for many years as the Prison Armory, now known as Tower Thirteen. The first floor of Tower Thirteen held solitary confinement cells known as the "dungeon cells." The second floor contained bachelor quarters. (This was where the guards slept when not on duty; when they had days off, they would ride their horses home until they had to return to work). The armory remained in this tower until 1911, when it was moved to Tower One. This photograph was taken in 1896.

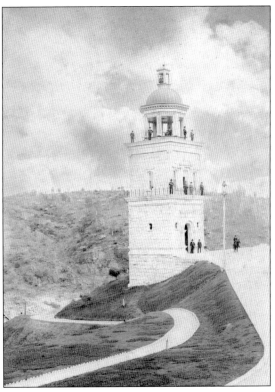

On March 1, 1880, Thomas C. Pockman was appointed warden of Folsom Prison by the board of directors and was ordered to select prison personnel and prepare for the reception of prisoners.

15

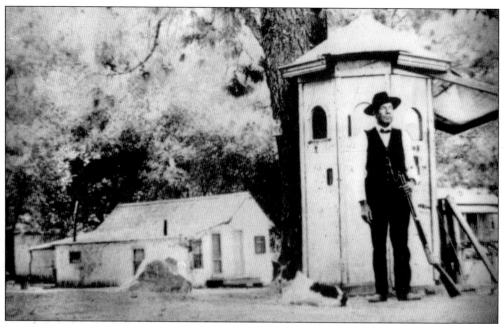

A few homes were on prison property from the Natoma Water and Mining Company days. They were used as housing for the prison administrators. Guards and prison employees would build wooden shanties (cottages, as some of the employees like to call them) on wooden skids, so they could be moved with the use of a team of oxen around the countryside of the prison. Other employees set up tents, and others stayed at boardinghouses in the town of Folsom. This Folsom guard and his trusty dog are on guard duty outside the prison but close to the staff homes. This photograph was taken in the 1890s.

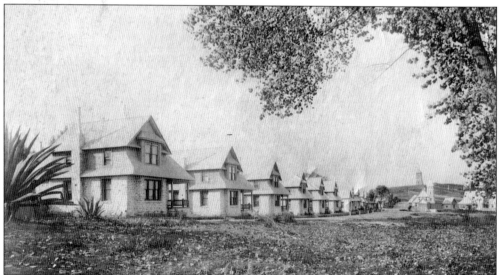

About 10 years later, the prison started construction of more houses for prison personnel. This was a necessity, as there was a severe housing shortage in the area. It was low pay working a prison job, unattractive unless a house on prison property and other fringe benefits were provided. To alleviate the situation, small houses were built on grounds that could be rented for a nominal sum to men with families. This was known as Valley Residence.

On July 26, 1880, the prison was formally opened to receive state prisoners and 44 of San Quentin's toughest were accepted on transfer. There was an argument among the prisoners and the receiving officers about which inmate should receive the first number. It was decided to everyone's satisfaction to enter one Chong Hing of Canton, China, as the number one boy of Folsom. These are mug shots of early prisoners taken in the 1880s.

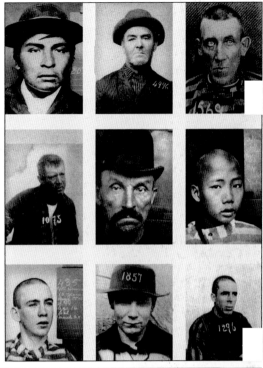

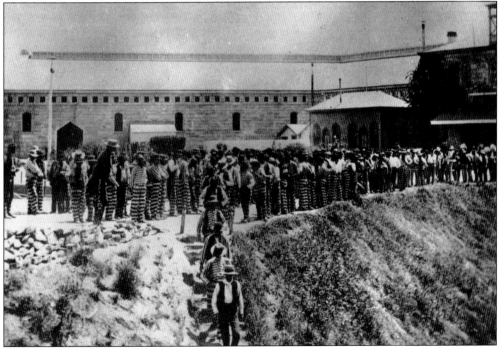

These prisoners worked seven and a half hours without a lunch and at 2:30 p.m. were marched back to their cells for lockup and standing count (prisoners stood at the front of their cell door to be counted to verify they were still in custody). This photograph was taken while prisoners are filing down to the lower yard rock quarry for work in 1918.

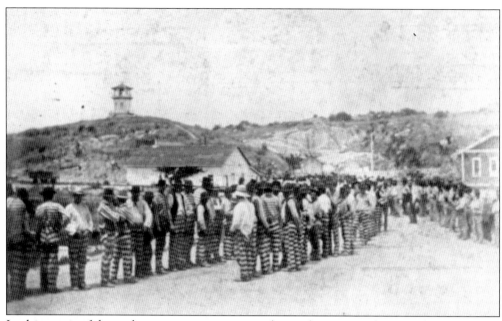

In the matter of dress, the inmates were permitted some leeway—perhaps not because of the wishes of prison authorities, but because no clothing was to be had. The men wore black-and-white striped pants of the barber-pole variety, which were first manufactured at San Quentin and then at Folsom, but each individual was permitted to keep the coat, vest, and hat he had worn on his arrival: This photograph was taken in 1918.

In November 1, 1881, under the wardenship of Gen. John McComb, the present prison yard was conceived and laid out.

Female prisoners at Folsom were almost a forgotten group. On April 9, 1884, the first woman prisoner was received at the prison. She was prisoner number 769, Kate Moriarty, who was sentenced to one year for burglary, second degree, from Alameda County. She was discharged on February 2, 1886. A total of 26 women prisoners called Folsom Prison home; some were only there for a few days. Female prisoners were subsequently transferred to the Women's Quarters at San Quentin Prison to complete their sentence. These prisoners were kept busy doing menial chores under the supervision of the warden's wife. In 1929, the practice of sending female prisoners to Folsom was stopped.

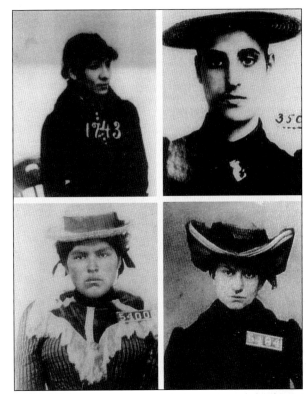

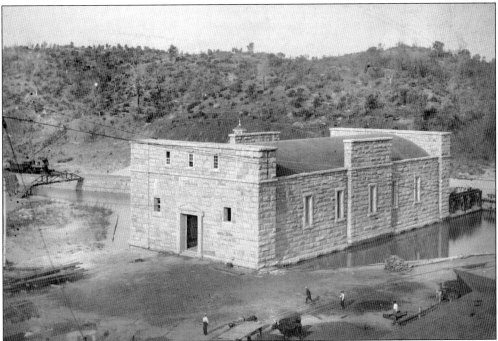

In March 1882, prisoners began work on the partially built dam and powerhouse that would be constructed on the prison property. Considering the site chosen and the fact that the work had to be done under such abnormal conditions, it is a wonder the task was ever completed.

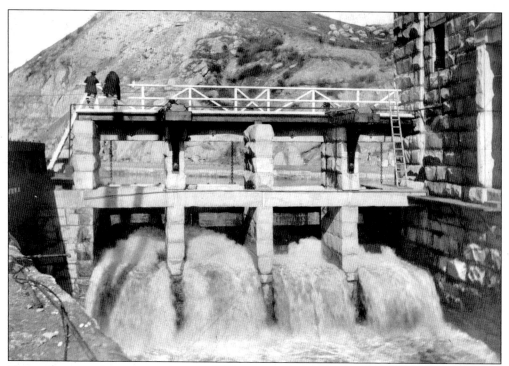

Notice the two prisoners, seen here in 1895, in striped uniforms and heavy coats atop the spill gates at the prison powerhouse, which served as a bypass for surplus water flow in the canal. The canal supplied the city of Folsom's powerhouse farther downstream.

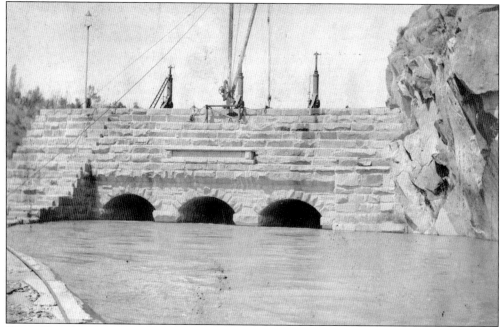

Water flowed under these granite arches into the canal, which supplied the prison hydroelectric plant, and later the water flowed to the city of Folsom's powerhouse. This photograph was taken in 1895.

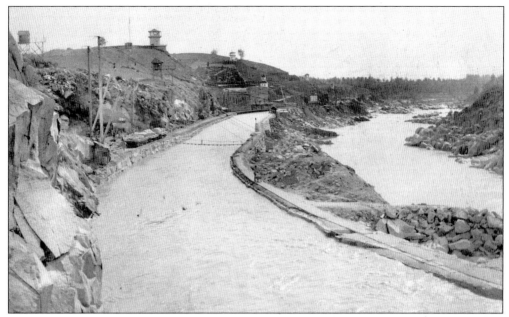

Looking down the canal from the dam toward the prison quarry in another 1895 view, notice the flatbed cars loaded with quarried rock at the left. The prison quarry was opened at various points on this hillside; the entire hillside was later quarried away. The canal was constructed from granite blocks, and in some areas, the granite hillside was cut out for the canal.

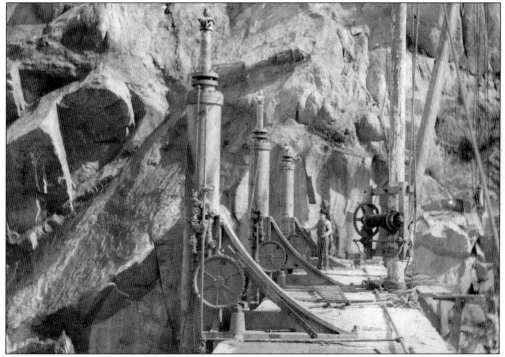

This equipment operated water gates, which regulated the flow of water into the canal that supplied the prison powerhouse and also the city of Folsom's powerhouse. Notice the prisoner standing in the 1895 photograph with his striped uniform pants.

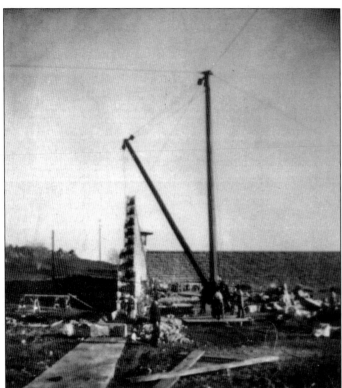

Construction began in 1884 on the wall, which was 30 feet high and 15 feet below the surface to prevent inmates from tunneling out. In 1922, thirty-eight years later, the walls around the prison were finally completed and guard towers erected at strategic points along its lengthy stretch. This wall, which enclosed some 41 acres, was built by convict labor exclusively. As the prison on one side faces the American River, a natural barrier, only three sides were enclosed. This photograph was taken in 1919.

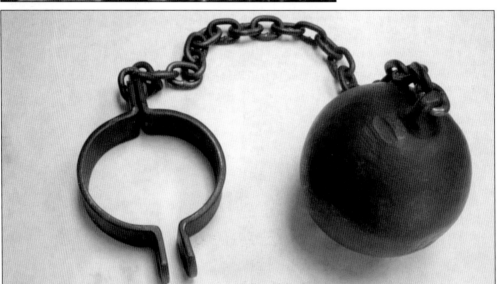

Some prisoners wore the ball and chain, which consisted of a cannonball weighing 25 to 30 pounds attached to short piece of heavy chain and the other end of chain attached to a metal shackle that was placed around the ankle and secured in place with a padlock or pinned with a bolt. A prisoner wearing the ball and chain could pick up the ball and was still able to run if he was strong enough to carry the ball in his arms. Prisoner slang called a convict with the ball and chain, "Having to carry the baby." The ball and chain was used in the early years of prison life for prisoners who had a history of escape.

Warden J. C. Gardner, of the Oregon State Prison, invented and patented the Oregon boot in 1866. It was manufactured at his prison by convict labor. Warden Gardner required every prisoner to wear the Oregon boot for the entire length of his stay. It was a thick steel doughnut that clamped around the ankle and was held up by a foot brace attached to the boot. The Oregon boot came in different weights of 6 to 15 pounds, which bolted around the ankle and could not be cut away. The Oregon boot was used at Folsom Prison to prevent prisoners from running in the early days.

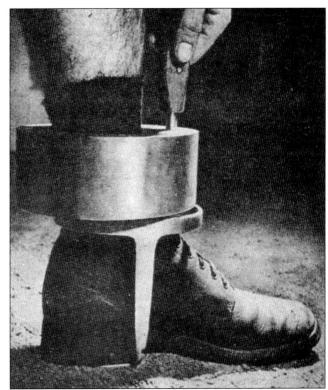

On December 26, 1887, Charles Aull was appointed to the wardenship and began the heavy job of running the wildest prison in California.

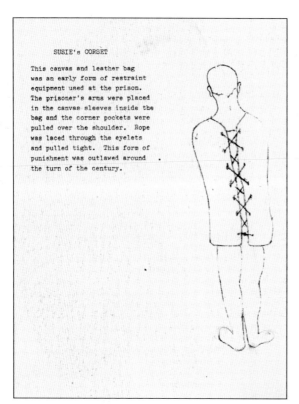

SUSIE's CORSET

This canvas and leather bag
was an early form of restraint
equipment used at the prison.
The prisoner's arms were placed
in the canvas sleeves inside the
bag and the corner pockets were
pulled over the shoulder. Rope
was laced through the eyelets
and pulled tight. This form of
punishment was outlawed around
the turn of the century.

The frequently used straightjacket was called by the convicts "Susie's Corset" or "The Bag." It was a canvas garment shaped like a coffin, wider at the top and tapered down to a smaller end, with large brass eyelets on both sides. The canvas would be laid out on the floor and the prisoner forced to lay face down on the canvas. The canvas would be wrapped around to the prisoner's back; then a heavy cord would be laced through the brass eyelets. A guard would then stand on the prisoner's back, forcing the air out of the lungs and stomach, getting his leverage and pulling, or "cinching" as the convicts referred to it, the cord as tight as he could. In some cases, two or three guards would take part in placing a prisoner in the straightjacket. Once tied up in the canvas, the prisoner would be left on the cell floor for varying periods of time.

One must not forget a little routine called "tricing" (meaning to be raised up off the ground and fastened to a large ring). There were several varieties of this form of punishment. A prisoner could be handcuffed to overhead rings or he could be tied by his thumbs in the same position. These rings were attached to the granite walls on the inside and outside of Building Five at differing heights.

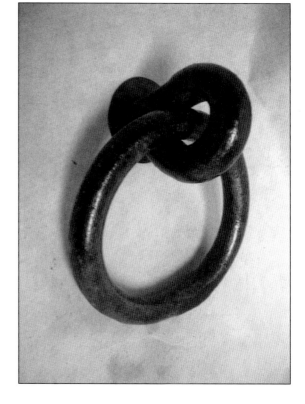

In the dark hours preceding the dawn of June 27, 1893, a discharged prisoner, William Fredericks, stealthily returned to the institution and secreted two rifles, two revolvers, ammunition, and some knives among the rocks of the quarry for his prison friends. He was later hanged for killing a bank clerk during a bank robbery. He was executed on July 26, 1895, at San Quentin.

The afternoon of June 27, 1893, while lieutenant of the guard Frank Briare (pictured here) was making his inspections of the quarry, he was suddenly seized by several convicts attempting to escape. The prisoners were Anthony Dalton (number 2538), Henry Wilson (number 1519), Frank Williams (number 2212), Charles Abbott (number 635), Contant (number 2760, alias George Sontag), and Charles Smith (number 426). The guards, after the first surprise of gunfire, returned fire and subsequently drove the convicts to shelter among the huge slabs of quarried granite. A pitched battle raged for almost half an hour, during which time three of the armed convicts were killed. The dead and wounded had been hit with a total of 64 rifle shots.

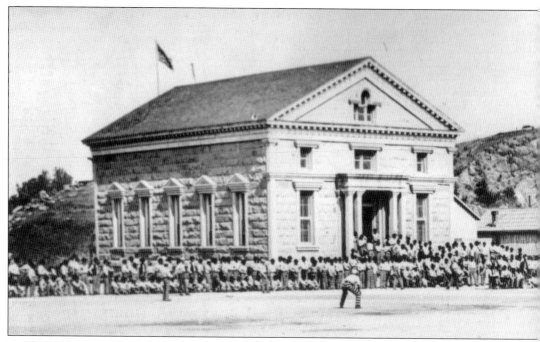

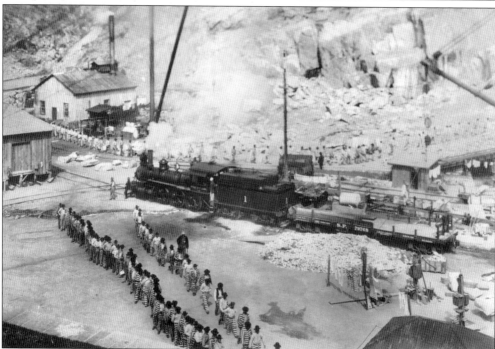

A locomotive was purchased to be used on a short-line railroad that had been constructed from the prison to the village of Folsom for hauling supplies. The train started hauling ice in June 1893 from the prison ice plant, with a daily capacity of 3 tons. The cost per ton was estimated at 50¢. The ice was used by the railroad for shipping produce across the country. The railroad shipped gravel from the rock-crushing plant at Folsom, which was used for roads in California. Notice the line of prisoners headed back up to the main yard at the end of the workday.

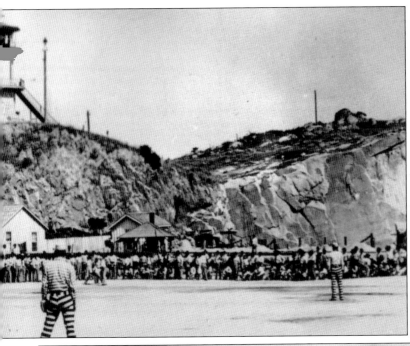

Prison baseball teams were organized, and games were played on Saturday afternoons, Sundays, and holidays. It was warden Charles Aull who began what is known today as Folsom's Field Day, held every Fourth of July. This photograph was taken in 1904.

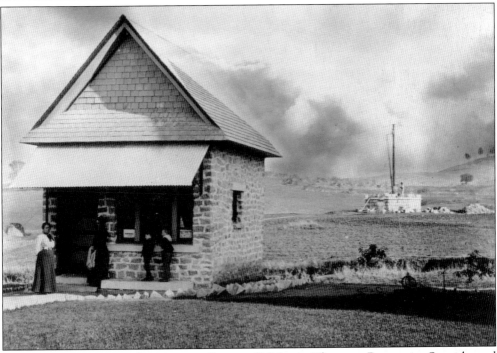

In 1895, the post office at the prison was Represa, California. The name Represa is a Spanish word for dam. History has it that the Spanish had built a rock and earth dam across the river to form a small pond so they could allow their livestock to drink water. This dam was in the location along the Rio de Los Americanos, later called the American River, on the present-day prison site. The idea for the name Represa was to protect prisoners' families from the embarrassment that came from having mail going to and from the state prison. This photograph was taken in 1898.

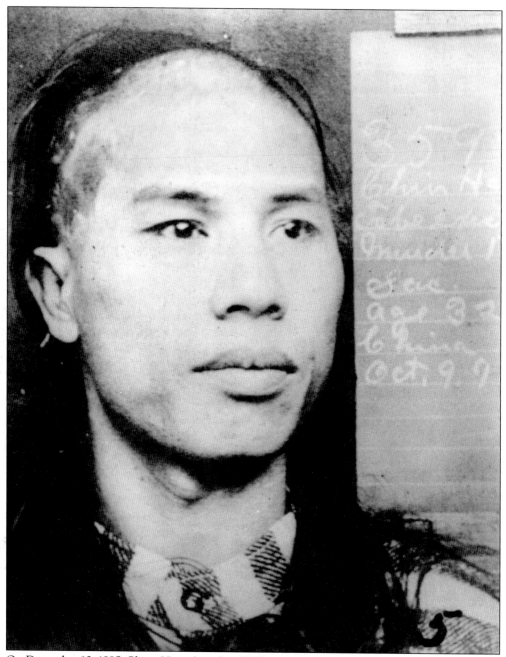

On December 13, 1895, Chine Hane (number 3595) was the first person executed. He was charged with the murder of Lee Tong, which was committed in the city of Sacramento during a gang fight between rival factions of the Tong Society (Chinese street gangs).

The original Death House was located in the Building Five area; it consisted of two tiers of condemned cells, four cells on the first tier and five cells on the second tier, that lined the same wall of the same room where the men were hanged. This area was called the "Condemned Cells." The two staff members standing in front of the Death House are assistant turnkey George Heggerty (left) and guard Royal Howard. The entrance to the Death House was all the way to the left, just out of site in this 1896 photograph.

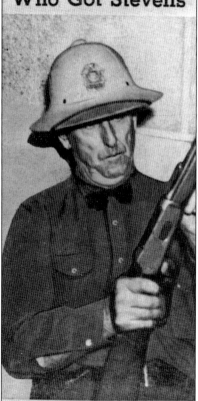

'Sure Shot' Guard Who 'Got' Stevens

H. B. Trader, prison hangman and "dead-eye Dick" with the gun and trigger fingers with which he shot and killed Clyde Stevens from the tower shown at upper right of page. His one shot was fatal.

The position of executioner was a volunteer job. The day of an execution, the executioner would receive an additional $10 and the afternoon off to relieve any tension from the execution process. Folsom's last executioner was H. B. Trader, who was a "sure shot" in his regular tower assignment.

The hangmen did their job very efficiently. The hanging rope sizes varied from three-quarters of an inch in diameter to one and one-quarter of an inch. Italian hemp was much favored, and an average rope consisted of five strands with each strand capable of holding up to 1 ton of dead weight. The knot that formed the loop in the rope used at Folsom was called a "submental knot" because it produced greater destruction of the vertebra. For example, if a man weighed 185 pounds, the length of rope would have to be prepared so the man would drop 6 feet, 7 inches in order to break his neck. Generally, the lighter the man, the longer the drop was needed to snap the man's neck. If the drop was not calculated right, the man would strangle, suffering a slow, agonizing death.

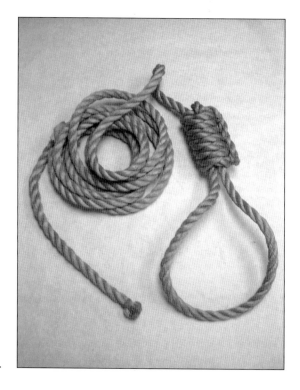

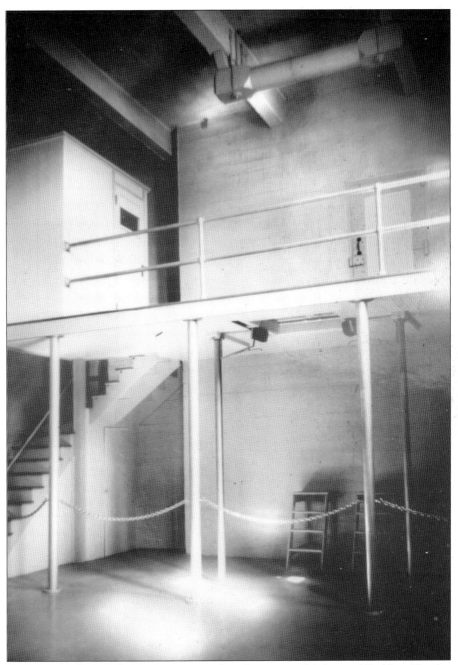

In the year 1931, the Death House was moved to the area in the front of Building Two because more space was needed for the witness viewing area. The condemned men were still celled in the old Condemned Cells. In this image, the beam attached to the ceiling anchors the noose, and the condemned man falls through the metal trapdoor at the center into the area below. The black ends on the rubber arms were installed to stop clanging noises when the man fell through the trapdoor. A subtle predetermined gesture, such as the warden putting his hands on his lapels, signaled the executioner to release the trapdoor while sparing the condemned man the stress of a countdown or tortuous waiting.

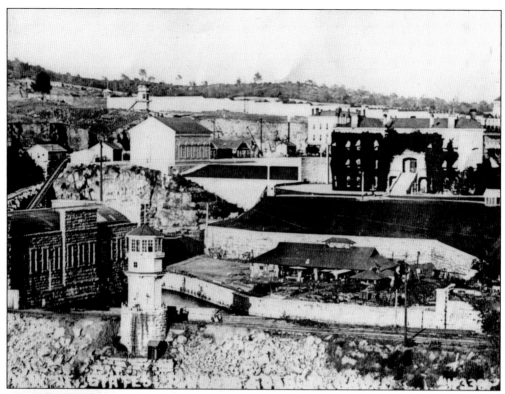

Humor was seldom evident among early Folsom prisoners, but on one occasion the men had a good laugh during warden Aull's tenure. On March 11, 1898, U.S. Secret Service agents surprised an enterprising group of prisoners at work in the blacksmith shop making counterfeit coins. Guided by an experienced counterfeiter, this nefarious crew had operated for over a year until an informant alerted authorities. The coins were used to buy opium and alcoholic beverages in addition to choice items of food in the prison black market. The blacksmith shop is located to the right of the tower below the Officers and Guards Building; the photograph dates to the 1920s.

On October 18, 1899, the governor appointed Thomas Wilkinson as warden.

Two

LIFE IN PRISON

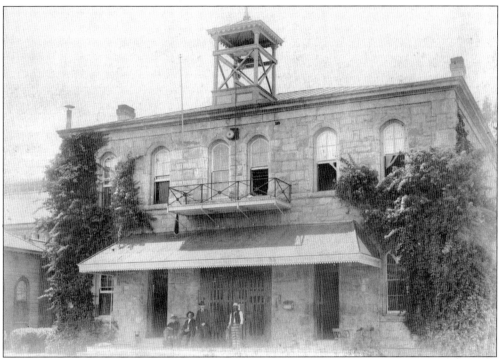

On July 27, 1903, the day dawned with the promise of being one of the warmest on record in the history of Folsom Prison. However, it was more than just another hot day. Guard William Cotter, on duty that morning, observed the interview line formed in front of the Captain's Office. This line was filling up with some of the prison's most desperate and dangerous men. He did remark that the line was headed by "Red Shirt Gordon" (so called because he wore the red shirt, which distinguished Folsom incorrigibles from the other convicts), and for a moment he was tempted to step forward and search him, but he quickly choked back the impulse. After all, he reasoned, it was the custom of warden Wilkinson and Captain Murphy to hold joint interview sessions with the prisoners at stated intervals, and this happened to be one of those days. The staying of that impulse was to cost Cotter his life. In this photograph of the Captain's Office, standing at the back of Gordon seemingly reading a book, was another of the prison's incorrigibles, Edward Davis. He was serving a term of 33 years for a robbery committed in San Francisco. Approximately half of the line was through the count gate when Davis, holding the book open in front of him, took a quick glance over his shoulder at the men in line behind him. Apparently satisfied with what he saw, he suddenly clapped the book shut, the prearranged signal for action. Davis lunged across the "dead man line" toward the Captain's Office 20 feet in front of him. Twelve grim-faced men brandishing knives rushed forward at his heels. Cotter had stepped to the entrance of the Captain's Office to supervise the order of the line, and the sudden rush of men caught him completely by surprise. He lifted his arms in a vain attempt to stop the convicts but without success. Knives glittered in the morning sunlight, and the guard fell to the ground fatally wounded.

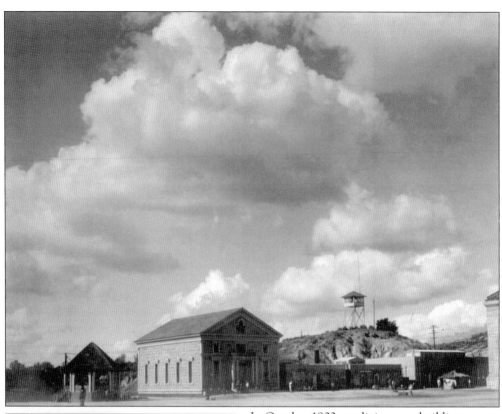

In October 1903, a religious-use building known as the Greystone Chapel was completed and put into operation. In 1938, the interior of the old building was remodeled and redecorated. Today it is used as a chapel for all faiths.

On December 1, 1903, Archibald Yell was appointed to the office of warden. The population had reached 763 prisoners that year.

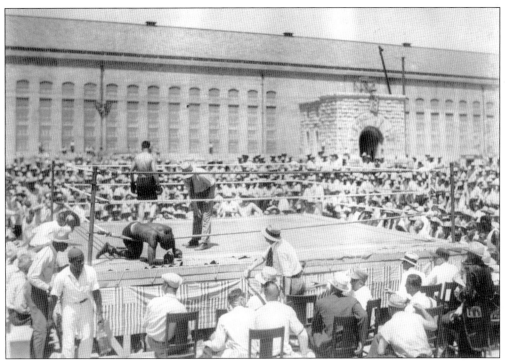

The first boxing matches were added to the Fourth of July celebration in the main yard, with a boxing ring consisting of a limestone chalk line laid out for the boundaries of the ring. This photograph was taken in the 1920s.

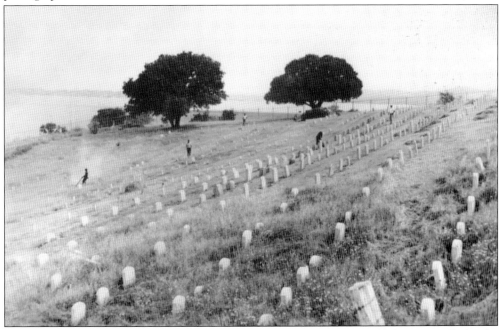

To some, the only way to escape seemed to be the prison cemetery, called "Boot Hill" by the prisoners. It was used from 1880 through 1959. On the hillside overlooking the prison are over 600 graves. This photograph was taken in 1955.

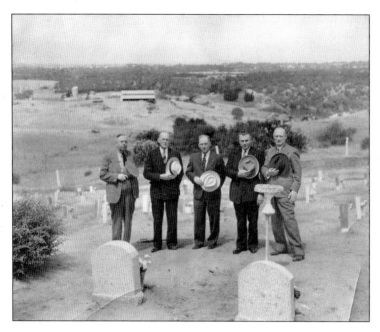

Starting in 1936, Capt. C. A. Larkin had a chaplain of the appropriate faith conduct a burial service and the flag at the cemetery was lowered to half-mast until the service was complete for the departed man while a convict played "Taps" on the bugle. On Memorial Day at Folsom Prison in 1944 are, from left to right, Capt. William Ryan, Rev. John Dunlap, Reverend La Salle, warden Robert Heinze, and Rabbi E. Coffee.

From 1907 to 1910, the East Gate was constructed along with the granite "shield" with the letters FSP chiseled into it above the walk-through gate. As staff pass through this portal, they look up and see the shield of Folsom State Prison—a shield of justice, courage, and pride.

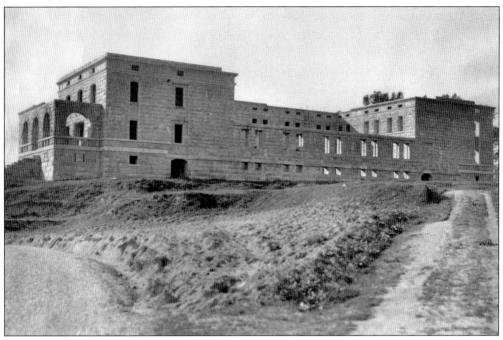

In 1907, the excavation had begun and the foundation was laid out for the main building. Two years later, the Hospital for the Criminally Insane was nearly completed. The hospital was never entirely completed, and no criminally insane patients were ever housed there. Some incorrigible prisoners were housed there, who referred to the hospital as the "Bug House." The word "bug" is a prison name for insane. The building was dismantled in the early 1950s.

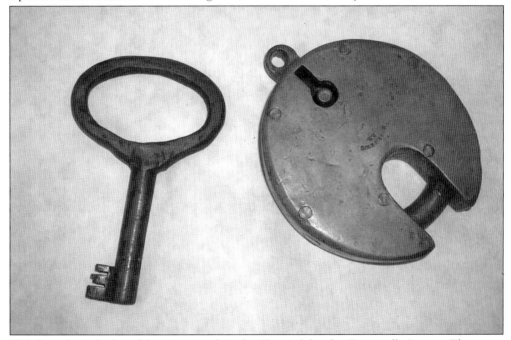

This large brass lock and key were used in the Hospital for the Criminally Insane. They were typical of those used during the early days of the prison.

W. H. Reilly
was appointed
to the warden's
position in 1908.

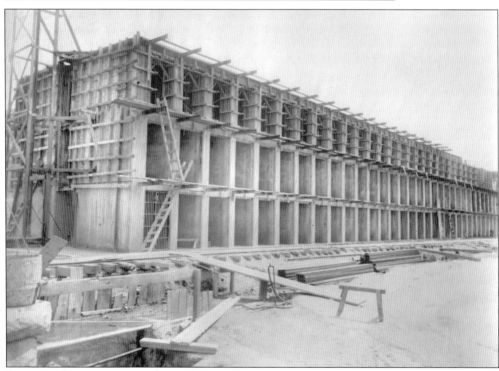

On December 2, 1911, ground was broken and cement floors laid for the first tier in the new cell block to be known as Building One. This building was to be of modern construction and was to embody the most advanced ideas in prison housing. It included a complete heating, ventilating, and plumbing system and was to be a marked improvement over the existing cell blocks.

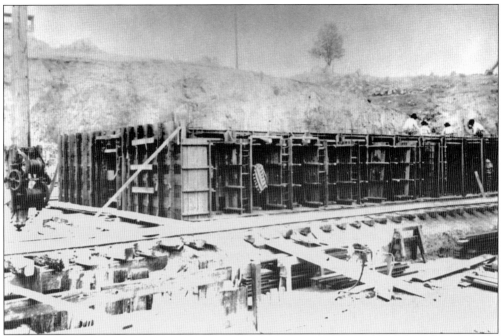

Construction on Building One was moving on with three tiers underway. The first tier was framed and concrete was poured; once it had set up and cured, the forms were moved up to the next level and the process repeated until they were done. This photograph shows the A/B section under construction.

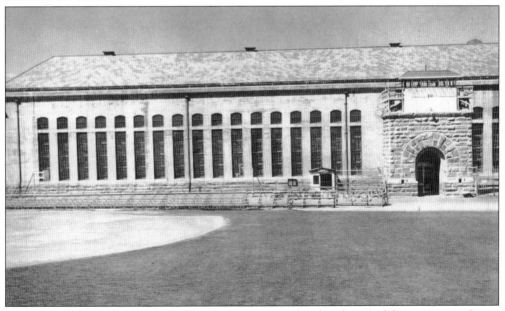

The new cell block, known as Building One, was completed and opened for occupancy. It was a vast improvement over the existing housing facilities and did much to alleviate the crowded conditions of the institution; it was the eighth-largest cell block in the United States. This photograph shows only half of the building; at the archway is the entrance. The Tower Eighteen sits above the entrance.

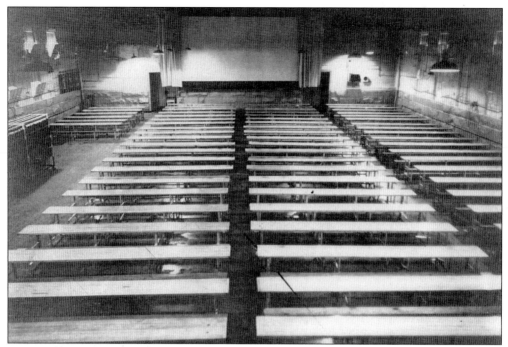

Dining Room One opened for dining and was a vast improvement over the old dining room. Notice the curtains on both sides of the movie screen; when not in use for a film, the curtains covered the screen. This photograph was taken in 1970.

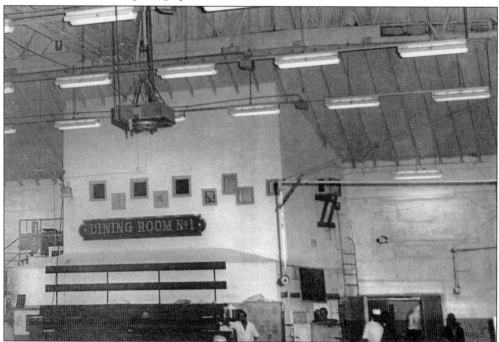

Seen here on November 8, 1952, is Dining Room One. When it was time to show a film, it was called the "movie house." Now it was finally officially named the Represa Theater. To the left in this 1970 photograph is a set of bleachers, which had a stairway to the projection room.

In the kitchen mess, seen here in 1910, the large cooking kettles were used for cooking massive amounts of food needed for the prisoners.

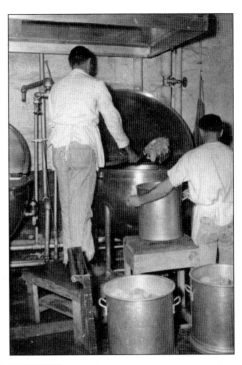

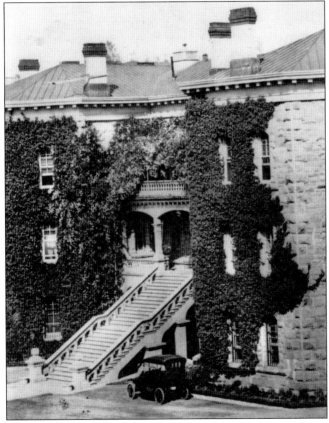

Up until 1914, the warden of Folsom Prison lived on the top floor of the Administrative Building. The second floor consisted of the Warden's Office, Accounting Office, Personnel Office, Records Office, and hospital. There was a steel door leading from the old cell block to the Administrative Building on this floor. There was also a staff dining room located on the second floor. This photograph was taken in 1911—notice the warden's automobile parked in front.

On June 1, 1912, James J. Johnston was appointed as the new warden.

A very old granite horse's head hitching post is still located outside the prison wall across from the Entrance Gate and museum. Since it was so close to the museum, there was no reason to attempt to relocate it and risk any damage to the artifact. In front of the museum is another carved hitching post in the form of a tree stump.

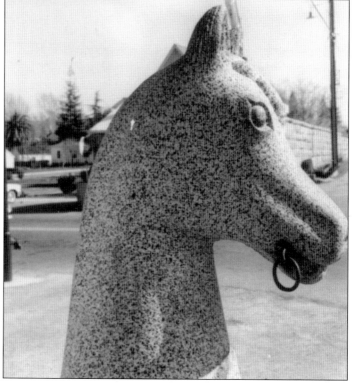

On July 11, 1913, the execution of one of California's most brutal killers, Jacob Oppenheimer, took place. He was known in both Folsom and San Quentin Prisons as the "Human Tiger." Although small in stature—5 feet, 6 inches tall and weighing less than 130 pounds—he was so ferocious that he was constantly watched by both prisoners and guards.

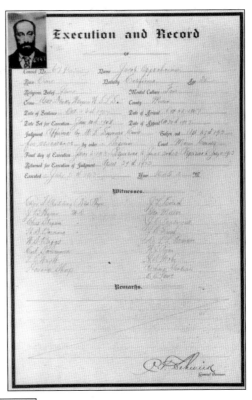

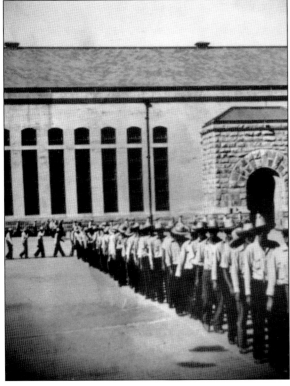

On November 6, 1913, the manufacturing of striped uniforms was done away with, changing to blue jeans and blue chambray shirts, which are still worn today.

Captain of the guard J. J. Smith was chosen as warden in December 1913.

In May 1914, the prison farm was expanded. A new dairy barn was built, and a number of cows were added to the small dairy herd; a swine herd of 66 sows, 2 boars, 12 shoats, and 45 hogs was begun.

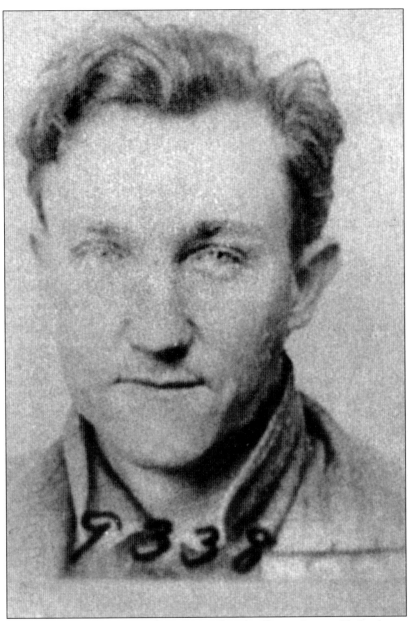

On October 16, 1914, Frank Creeks (prisoner 9336) and cellmate George Phelps (prisoner 8149) made a sensational dash for liberty. Using an improvised key and arming themselves with knives and a dumbbell, they attacked night sergeant John Drewry and guard Joe Kerr during night inspection. Drewry, a 46-year-old father of four, was stabbed to death by Creeks. The escaping prisoners got through the front gate of the cell house and started to run across the prison yard to the quarry steps. Kerr drew his gun and fired, dropping Phelps with a bullet through his head. Guard Frank Maher, located in the yard tower, fired at Creeks, who stopped long enough to exchange shots with him, inflicting a severe wound in Maher's leg. His leg became infected while in the hospital, and after 12 days he died. Creeks made good his temporary escape but was captured two days later in a rooming house in Loomis, California. Taken back to the prison, he was tried and convicted for the killing of Sergeant Drewry and sentenced to hang.

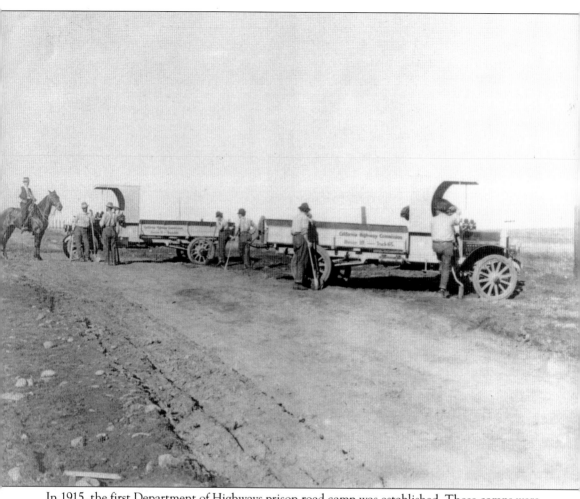

In 1915, the first Department of Highways prison road camp was established. These camps were the forerunners of the state prison's Conservation Camp Program.

In December 1915, the warden's house was completed, and it was called "The Wardens Mansion." Now the mansion is utilized as the Business Services and Personnel Office.

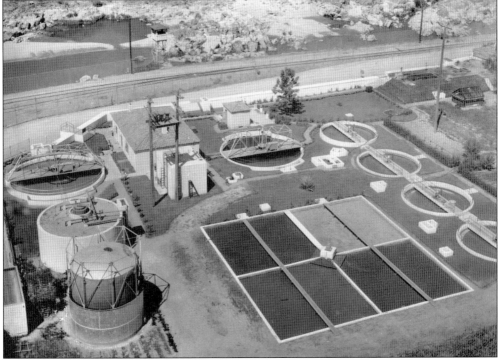

In 1918, a sewage disposal plant was completed in the lower yard. This was the first disposal plant at the institution, since the river was used for this purpose prior to the building of the plant. In 1932, a modern sewage disposal plant was also completed and placed in operation. This plant embodied some of the newest and most revolutionary methods in disposal work; sanitation authorities throughout the West have visited the prison to see it in operation. This photograph was taken in 1935.

In 1919, the construction of the Education and Recreation Hall (now the Visiting Room) had begun, and it was completed in 1923. It was to be a combined school building and auditorium in which picture shows and diversified entertainment could be held. This photograph is the Education Building to the left, Building Two in the center back, and the Administrative/Hospital Building to the right. Visitors can be seen sitting on the visiting patio in this 1978 photograph.

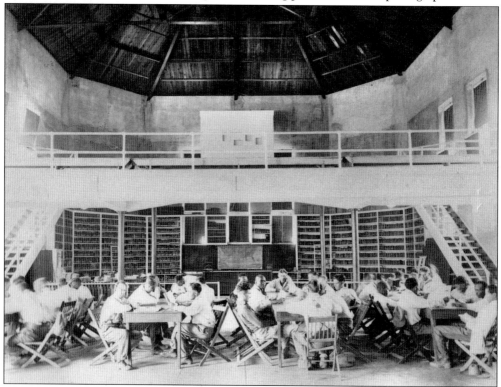

This 1950s image of students in class learning their ABCs shows it is never too late in life to get an education. This building had a stage, which was used for a variety of vaudeville-style acts.

On June 23, 1924, Capt. Patrick J. Cochrane was accidentally killed when the masthead of a derrick in the lower yard fell and struck him.

STATE PRISON AT FOLSOM

PRISON MESS

BILL OF FARE

MONDAY June 15th 1925 TUESDAY June 16th 1925

BREAKFAST BREAKFAST
Stewed Prunes Syrup Hot Buns Hamburger Steak with Brown Gravy
Coffee Brown Beans White Bread Steamed Potatoes White Bread

DINNER DINNER
Spanish Stew with Vegetables Corned Beef Hash Brown Gravy
Macaroni Brown Beans Tea Brown Beans White Bread
Tea White Bread

SUPPER SUPPER
Macaroni Vegetable Soup Brown Beans Spanish Beans Brown Beans
Coffee White Breas Coffee White Bread

WEDNESDAY June 17th 1925 THURSDAY June 18th 1925

BREAKFAST BREAKFAST
Sugar Cracked Wheat Brown Beans Hamburger Steak with Brown Gravy
Coffee White Bread Steamed Potatoes Brown Beans
 Coffee Corn Bread

DINNER DINNER
Pig Knuckles Steamed Potatoes Lima Beans Lamb Curry & Rice Brown Beans
Tea Brown Beans White Bread Tea White Bread

SUPPER SUPPER
Split Pea Soup Brown Beans Tapioca Brown Beans
Coffee Brown Bread Coffee White Bread

FRIDAY June 19th 1925 SATURDAY June 20th 1925

BREAKFAST BREAKFAST
Stewed Peaches Syrup Hot Buns Sugar Rolled Oats Brown Beans
Coffee Brown Beans White Bread Coffee White Bread

DINNER DINNER
Cod Fish Potatoes in Cream Baked Beans Beef Stew with Vegetables
Tea Brown Beans White Bread Baked Spaghetti Brown Beans
 Tea White Bread

SUPPER SUPPER
Spanish Beans Brown Beans Lima Beans Brown Beans
Coffee Whole Wheat Bread Coffee White Bread

SUNDAY

During meal time, the food usually consisted of beans ladled onto tin plates, though other items were served when available. Inmates received a vile unsweetened chicory coffee, black as tar, usually with a piece of dry, coarse white bread. Here is the weekly menu from 1925.

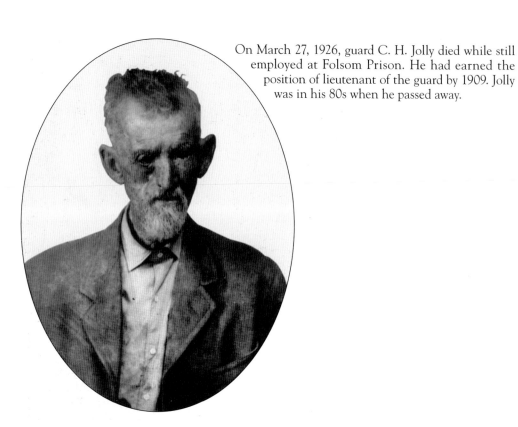

On March 27, 1926, guard C. H. Jolly died while still employed at Folsom Prison. He had earned the position of lieutenant of the guard by 1909. Jolly was in his 80s when he passed away.

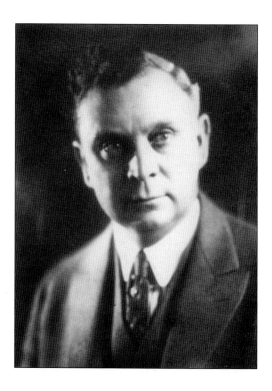

On March 1, 1927, Court Smith was appointed as the new warden. He had served as chief of police in Visalia and sheriff of Tulare County.

Dr. Proctor W. Day was hired as the new prison physician on September 1, 1927. He started work as a medical officer at San Quentin Prison and later transferred to Folsom. Pictured from left to right are guard Charles C. Gillespie, Dr. Day, warden Robert A. Heinze, and prison director Richard A. McGee.

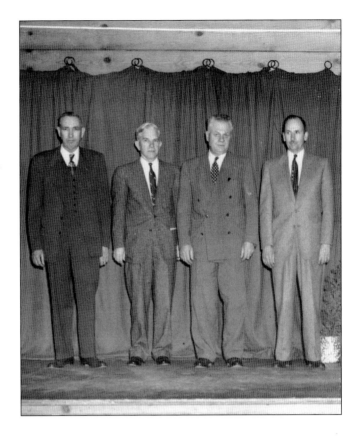

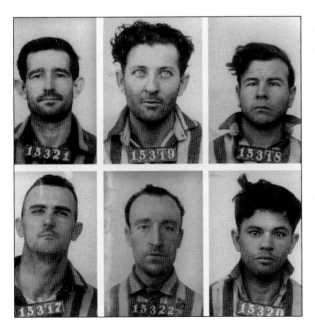

Thanksgiving Day 1927 saw a desperate escape attempt by six prisoners. They had smuggled in a .45-caliber pistol along with two straight razors, a hatchet, and assorted knives and planned to overpower guards who would let them out at the outer gates. The men involved in the scheme, from left to right, were (bottom row) Walter Burke (15317), Al Stewart (15322), and Tony Brown (15320); (top row) James Gregg (15321), James Gleason (15319), and Roy Stokes (15318). The would-be escapees panicked, hustling guard James Goranhson to the north side of the cell block to force their way through the gates (located in the middle of the building on the north side of Building Five) leading to the prison yard, but these were locked.

Picked up en route to the gates, turnkey Walter Neil (pictured here) was forced to ask that the first gate be opened, and the convict trustee did so. Goranhson stumbled through followed by Neil, who suddenly slammed the gate shut in the faces of the astonished convicts. One of them fired the heavy automatic, striking Neil in the leg. The guards reached the outer gate, which was opened by guard Frank Thompson. A second shot missed both Goranhson and Neil but went through the outer gate, killing prisoner 11372, George Baker. Capt. C. A. Larkin summoned a doctor, while the inner gate effectively trapped the six increasingly desperate prisoners inside the cell block.

After a hurried consultation, the attempted escapees proceeded to the auditorium, where they hoped to lose their identity among the 1,000 or more men gathered there for the movie show. In the doorway of the school building, they encountered assistant turnkey Ray Singleton (pictured here), who upon resisting their entrance was killed with the hatchet, knives, and straight razor. Guard Bernard Deely came to his assistance and was stabbed several times for his efforts.

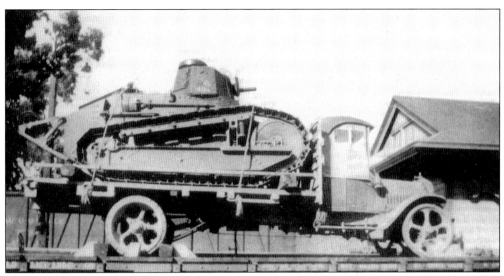

A general alarm had been sounded by warden Court Smith, the new appointee to the wardenship. The building had been surrounded by armed guards. In addition to the 500 state militiamen, Sacramento police and sheriff's officers had been called out from Sacramento; they took up stations along with the prison guards. Two army tanks and two planes carrying bombs and machine guns were used at the prison.

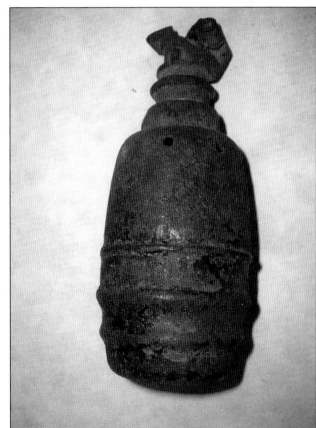

Many canisters of tear gas were lobbed into the cell block to help put the escape down. It was more like a war zone with shots being fired back and forth. This is one of the canisters recovered by prison staff in 1927 and years later donated to the museum when it opened.

Charles B. Gillies (pictured here), a guard in charge of the Entrance Gate, dropped dead of heart failure at his post from the excitement. He was hired on at the prison on October 1, 1897, as the armorer in charge of maintaining and repairing prison weapons. He was 66 years old.

Brown, Stokes, Gregg, Gleason, Burke, and Stewart were first tried in the Superior Court at Sacramento for the murder of Singleton. They were found guilty and sentenced to life imprisonment. They were then tried for the murder of inmate George Baker (pictured here). The six were found guilty of murder in the first degree and sentenced to be hanged. After two appeals, five of the men were hanged at Folsom Prison in January 1930. The sixth man, Stewart, who testified against the others, received life.

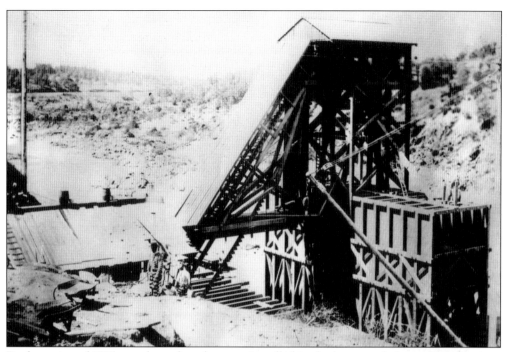

By the spring of 1895, a rock-crusher plant was installed in the lower yard quarry. The river is to the right of the rock crusher in this 1899 photograph.

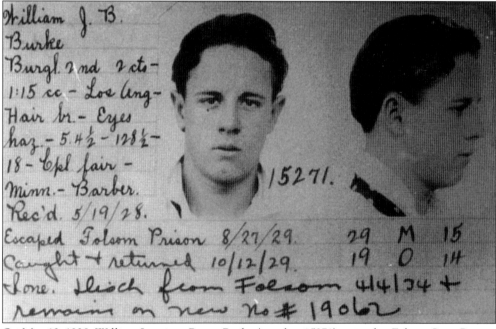

On May 19, 1928, William Jennings Bryan Burke (number 15271) arrived at Folsom State Prison. While working for carpenter Glenn L. Henry at the prison, Billy told Henry about an article he had read about a man building a 6-foot-high model of the Eiffel Tower out of toothpicks. The next day, Henry tossed a box of toothpicks on Billy's deck and told him, "After your work is completed, build something."

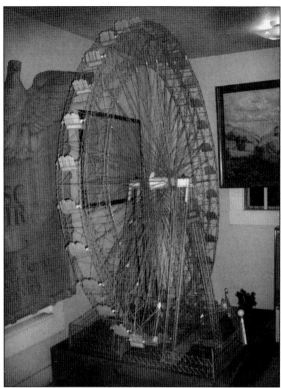

Billy Burke started constructing an 8-foot-high Ferris wheel, completed 10 months later with over 250,000 toothpicks. Some figures were placed on the platform watching the carnival as the Ferris wheel was turned by an electric motor. He was discharged from Folsom Prison on April 4, 1934.

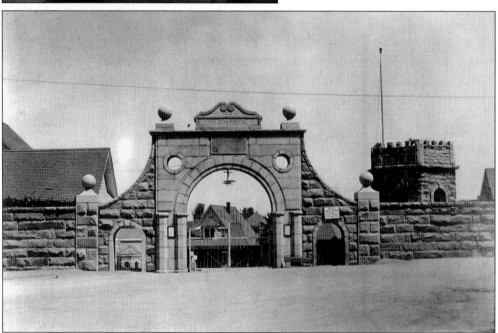

In the late 1920s, the arched gateway was removed from the main entrance gate to accommodate the larger trucks that transport food items and other supplies to the prison for use in the daily routine. The roof line to the left is the Represa Post Office, and the building to the right with the flagpole is the Registration Post, constructed in 1900.

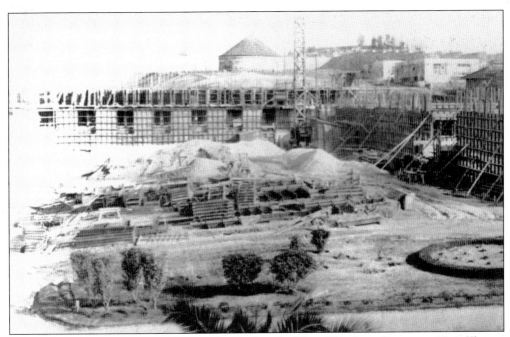

The new cell building, known as the "Annex," or Building Two (now known as Unit II), was completed in January of 1931 and immediately occupied. This 1929 photograph shows Building Two in the center and the Administrative/Hospital to the right under construction.

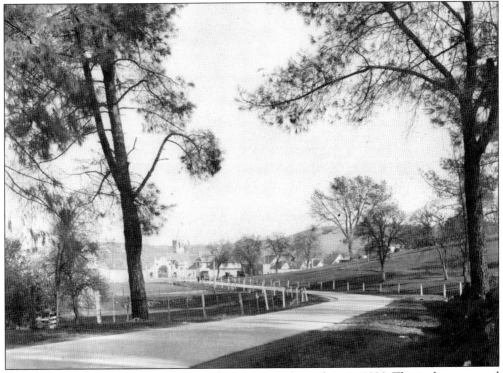

The road leading to the Entrance Gate of the prison is shown here in 1930. This is the same road today that people drive down to the entrance of the prison.

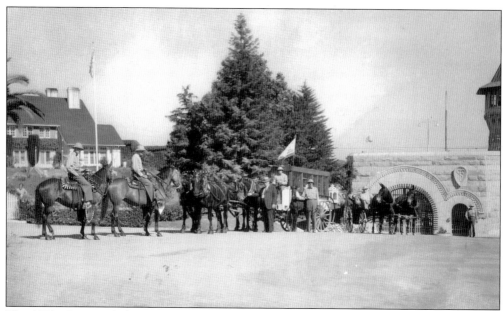

This 1930s photograph shows two members of the Sacramento Sheriff's Mounted Patrol, the Folsom Prison caged wagon for transporting prisoners, and the warden's buckboard. They are getting ready to enter the prison through the East Gate for a Fourth of July parade in the main yard.

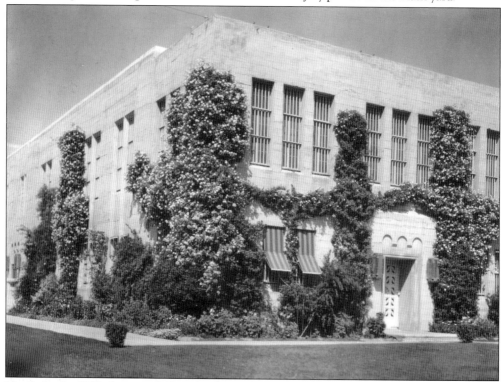

Notice in this 1938 photograph that the third floor to the hospital has not been constructed; this was completed in 1942. The two striped canvas window awnings are the Warden's Office windows. In the 1970s, the Administrative Building was completely covered with climbing plants.

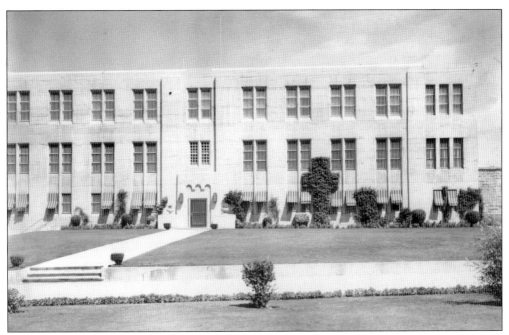

Administration offices were located on the first floor of this building, and the hospital was located on the second and third floors. The hospital was completely fitted with new equipment. This photograph was taken in the 1950s from near the Education Building, now the Visiting Room.

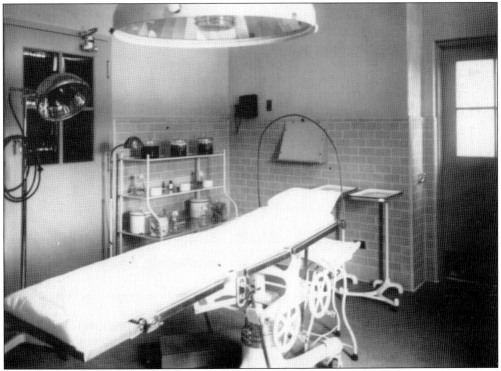

This photograph shows the surgery room with the table and equipment needed to perform all medical procedures at the prison. This room was at the far north end of the third floor of the hospital.

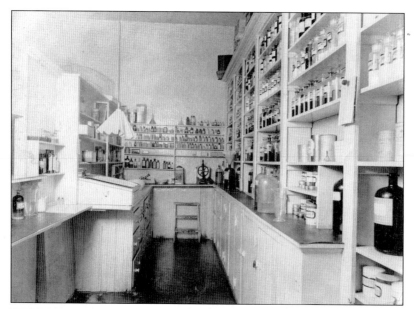

This late-1930s image shows the prison pharmacy room with all the medicine lined up in bottles and glass containers to be dispensed to the patients. This photograph is displayed in the same area of the hospital where the pharmacy sits today.

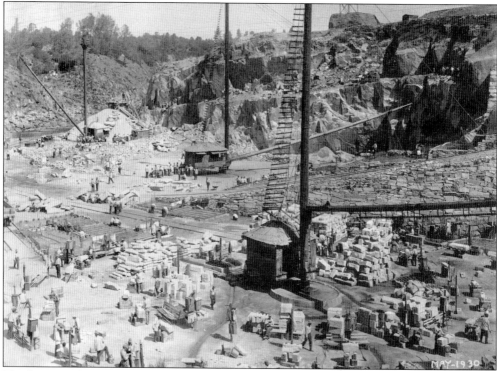

The lower yard rock quarry was known for "making little ones out of big ones." Over 150,000 tons of cut finished granite were used on the grounds to build the prison, while other granite was shipped to other construction projects throughout the state. The three tall derricks once dominated the quarry, as seen in this May 1930 image. The derricks were used to move the large blocks of granite; the pathway going upward from center left to right was for transporting quarry stones up to the different building sites around the prison as well as supplies brought in by the train up to the main prison.

This photograph was taken in the early 1940s from the lawn area in front of the Officers and Guards Building looking east toward Tower Fifteen, which was constructed on the wall overlooking the West Gate and main yard. Just to the left of the tower wall is the prison library. Notice the heavy steel shooting shield and chair out on the wall.

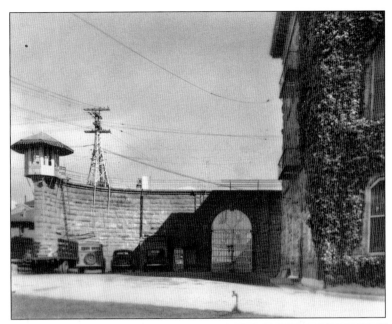

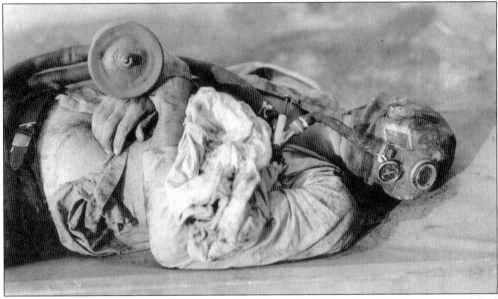

On September 14, 1932, there was a bizarre escape attempt at the prison. A prisoner named Carl Reese had fashioned a diving helmet, consisting of a football bladder with one goggle eyepiece cemented into it. It had a tube for air with a float to carry the tube to the surface. In the float was a valve with a string attached, which could be opened at will by Reese, ensuring an ample supply of air while he was beneath the surface of the canal water. During the afternoon, Reese managed in some way to cut a hole through the chain-link fence surrounding the powerhouse mill pond and canal and crawled through unobserved by tower guards. He proceeded to fill his pockets with scrap iron to weigh himself down, then slid into the pond and settled to the bottom. Apparently misinformed as to the depth of the water, he opened the valve, but the float was still a few feet from the surface. Water flowed in instead of air, and as he was unable to empty his pockets of the iron and rise to the surface, Reese drowned.

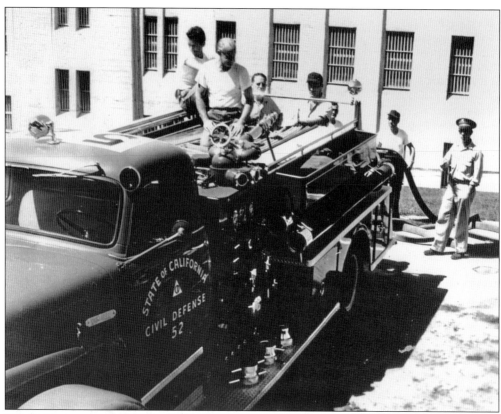

The firehouse was completed in 1932 and another fire engine purchased, making two in use at that time. This photograph was taken in the 1950s at the firehouse located next to the Administrative Building between the wall and Tower Two. This area now houses Family Visiting Units. The officer is Chet Burnett, also the fire chief. In 1976, the firehouse moved outside the prison walls next to the camp, which is its present location.

COMMISSARY DEPARTMENT

STATE PRISON AT FOLSOM

REPRESA, CALIFORNIA

February 1, 1933

Report of Meals and Commodities Required therefor at Folsom Prison.

Population	2798
Inmates who do not eat	
at the General Mess:	
Hospital Patients	46
Hospital Help	30
Warden's Help	5
Officers and Guards Help	13
Total at General Mess	2704

This commissary report from 1933 shows the amazing amount of ingredients it takes to prepare a meal for over 2,704 prisoners. The mess has always had many inmate kitchen workers preparing the meals under the watchful eye of the civilian culinary staff, who train inmates in proper food-preparation techniques.

COURT SMITH
Warden

EUGENE G. FITZGERALD
Commissary

62

On February 2, 1933, prisoners Lloyd Sampsell and Martin "Silent" Colson armed themselves with homemade pistols and ammunition and forced their way into the Administration Building by way of the hospital. An alarm was sounded and the Administration Building surrounded by armed guards. Realizing the futility of the venture, Colson retired to a washroom and calmly blew his brains out. Sampsell surrendered and was placed in solitary confinement. Sampsell was executed at San Quentin on April 25, 1952.

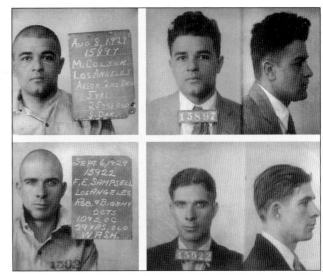

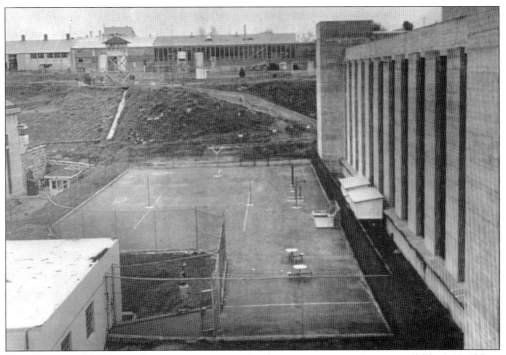

The summer of 1934 saw the excavation start for the construction of a new cell block, Building Three. This cell block had 400 cells and could hold two men to a cell for a total of 800 prisoners. This 1960s photograph is looking north; the building to the right is Building Three, and the building at the front left is Building Four. Structures behind the tower are the tag plant and cannery.

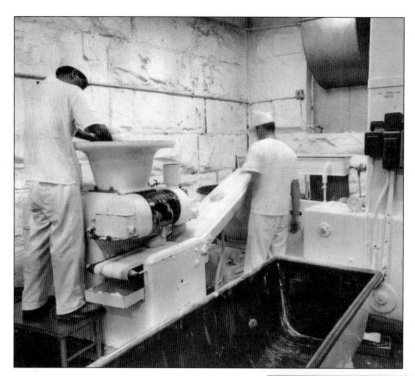

In 1936, the prison mess hall had all new equipment installed in the bakery, including a reel oven, ensuring a plentiful supply of freshly baked goods. An average of 1,500 two-pound loaves of bread was baked daily. This photograph was taken in the 1960s.

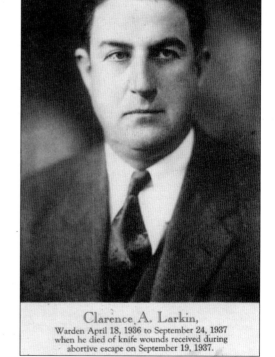

Clarence A. Larkin,
Warden April 18, 1936 to September 24, 1937
when he died of knife wounds received during
abortive escape on September 19, 1937.

Captain of the guard Clarence Larkin was elevated to the wardenship of Folsom on April 18, 1936.

In 1936, a concrete balcony, called the Captain's Porch, was constructed immediately in front of the Captain's Office. It was to be used by visitors and dignitaries on various occasions.

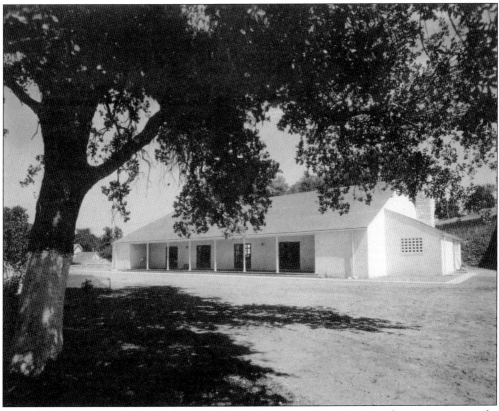

Preliminary work was begun outside of Folsom Prison's walls in 1936 on the construction of a recreation hall, now known as Larkin Hall. It was made for the officers and guards of the institution and is now used for in-service staff training.

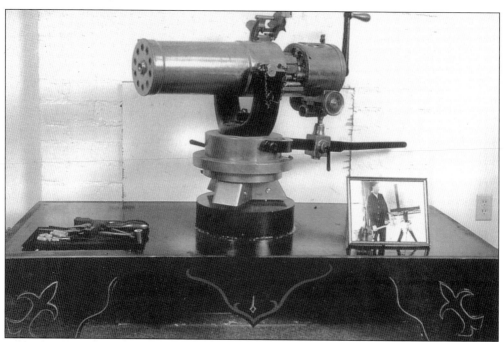

Warden Larkin gave the last two Gatling guns from the prison to the Folsom American Legion Hall in 1937. They stayed there for several years until Jack Kipp took them to the Folsom Police Department and had them secured there. A few years later, a Folsom police officer named Richard Lavalino decided to clean up and restore them. The best one was a rare 10-barrel with a covered shroud; this gun has 10 barrels symmetrically placed around a central shaft, which fires the 45-70-caliber round. This specimen was donated to the Retired Correctional Peace Officers Museum in 1994.

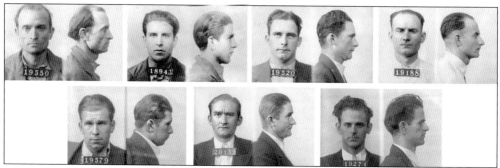

On September 19, 1937, warden Larkin was conducting interviews with prisoners in the Captain's Office along with Capt. William J. Ryan. On the "deadline" directly in front of the Captain's Office were prisoners Wesley Eudy (19271), Benny Kucharski (20139), Robert Cannon (18943), Fred Barnes (19550), Ed Davis (19188), Clyde Stevens (19520), and Bud Kessell (19579). Warden Larkin glanced at the next interview name on the list and picked up the corresponding prison record card. He ordered Eudy sent in.

Hardly had Eudy stepped through the door when the rest of the conspirators raced toward the office. Warden Larkin was inquiring into the nature of Eudy's request for an interview when the screaming men suddenly entered. Eudy whipped out a knife and automatic pistol and immediately demanded the surrender of the two officials. This photograph shows Folsom Prison's Jack Whalen displaying the 10 knives, 2 dummy automatic pistols, and club to reporters after the incident.

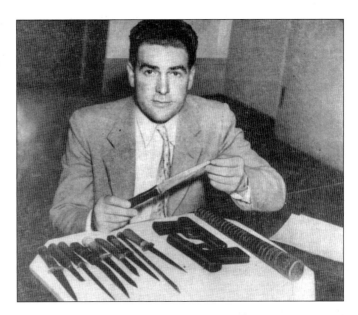

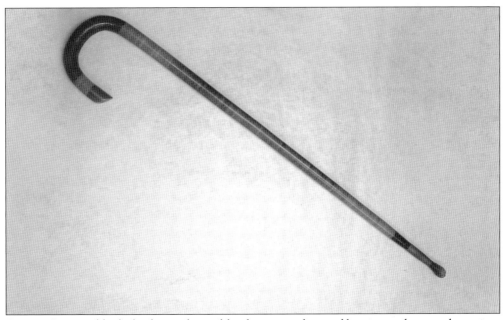

Captain Ryan grabbed a lead-tipped cane like this one and started beating at the armed convicts. Barnes, Kessell, and Stevens assaulted him, severely wounding him in the shoulder. The two were quickly overpowered and, with knives held at their throats, were bound fast with their hands behind them. A wire loop was placed over the warden's head and pulled tight around his neck. Larkin, bleeding at the neck, attempted to reason with the convicts. "Shut up and get the hell out the door," growled Davis. "We're going out of this prison and if anyone gets hurt it will be you. Sure we'll die, but you can depend upon it, Larkin, you'll die first." Cannon and Kucharski stabbed guard Harry Martin through the heart. Mortally wounded, he backed painfully out of the door. Guard James Kearnes at the count gate quickly sprang forward and helped him through the door. Horrified at what Martin told him, he locked the gate and sounded the alarm.

THROW DOWN YOUR GUN!

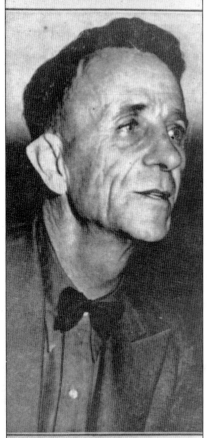

TOWER GUARD—Joseph Brady, Folsom tower guard to whom the convicts called: "Throw down your gun or we'll kill the warden!" He was called as a witness.
—Photo by San Francisco Examiner.

In moments, the office was surrounded by guards carrying heavy lead-tipped canes. Out of the office door stepped warden Larkin, Eudy holding his left arm. Directly in back of him came Captain Ryan flanked by Kessell and Barnes. Cannon, Stevens, and Kucharski, brandishing knives, quickly followed, and the tight little group huddled in the center of the walk under the Captain's Porch. Davis leaned to the outer edge of the walk and called up to guard Joseph Brady in the gun tower above to hand down his rifle. "Come out a little further and I'll let you have it," he said. Shots rang out, and Stevens, standing at the side of the warden, crumpled to the ground. Guards leaped in and began wielding their canes. Warden Larkin broke loose from his captors but in the process was stabbed by Eudy and Davis; he collapsed about 15 feet from the walk. In the melee that followed, Captain Ryan was repeatedly stabbed, finally falling on a bench by the side of the outer office wall.

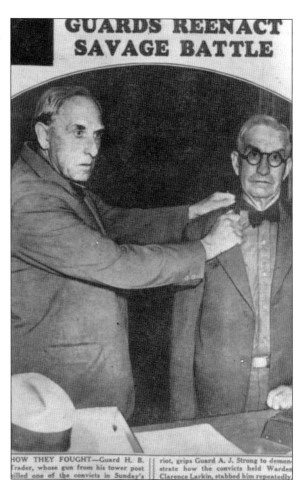

GUARDS REENACT SAVAGE BATTLE

HOW THEY FOUGHT—Guard H. B. Trader, whose gun from his tower post killed one of the convicts in Sunday's riot, grips Guard A. J. Strong to demonstrate how the convicts held Warden Clarence Larkin, stabbed him repeatedly

Guard H. B. Trader, in Tower Thirteen, shot Stevens between the eyes as he was stabbing the warden. Trader then fired another shot, dropping Kucharski. The next shot, fired by guard A. J. Strong from Tower Twenty-one, hit Barnes in the shoulder, knocking him to the ground as he was assaulting Captain Ryan. Eudy was shot through the eye, and guard E. C. Bigelow broke his cane over Cannon's head, knocking him unconscious. Davis and Kessell were knocked senseless by guards with lead-tipped canes.

68

Five days later, warden Larkin died in his wife's arms at the age of 46. This photograph was taken as warden Larkin's casket was removed from Sacramento's Memorial Auditorium after the memorial service.

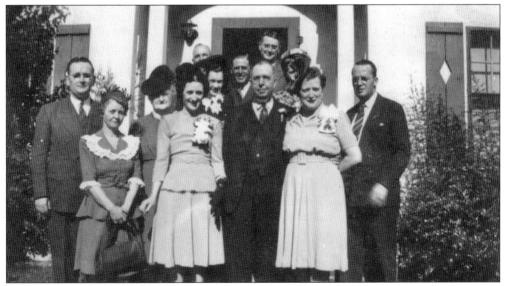

Captain Ryan (first row, second to the right), in Mercy Hospital of Sacramento, was given a 50 percent chance of recovery, but with his faith and strong will to survive, he was released in one month. While in the hospital, he met a nurse named Margaret Dugan (to the right of Ryan); they fell in love and were married on August 22, 1942. This photograph was taken on the front porch at Captain Ryan's prison residence.

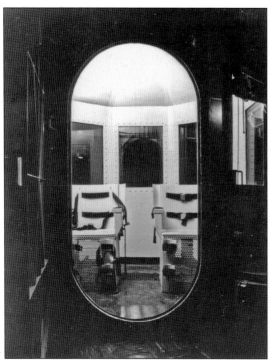

Eudy, Barnes, Cannon, Kessell, and Davis eventually recovered and were brought to trial for the death of warden Larkin. All were convicted without recommendation, transferred immediately to San Quentin and, in December 1938, went to their deaths in the lethal gas chamber shown here.

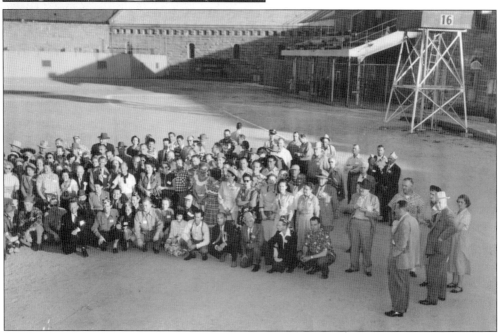

In 1937, after Captain Ryan recovered and returned to work, he made several changes and added some new security ideas. The first was to construct Tower Sixteen in its current location and install a chain-link fence and gate around the old Five Count Gate and Captain's Office area. The new tower could electrically operate the gate and control inmate foot traffic. This photograph was taken on October 25, 1950, while warden Robert Heinze was conducting a group on a tour of the prison.

Captain Ryan had a gun cage placed inside and above the Captain's Office, which was armed by a staff member with only a revolver because of the small size of the cage. The only way to enter this post was from a trap door located upstairs in what is now the Inmate Assignments Office. This gun cage is still above the watch sergeant's desk, out of sight because of the ceiling covering it. This photograph was taken in 1997.

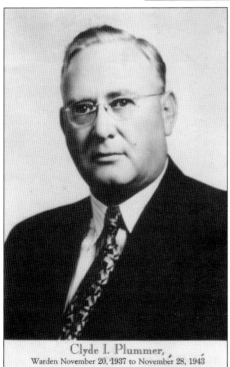

Clyde I. Plummer,
Warden November 20, 1937 to November 28, 1943

The board of directors appointed Clyde I. Plummer as warden on November 20, 1937. He had been connected for many years with police officers and was well suited for the post.

71

In 1938, approximately 1,220 acres of prison reservation were set aside for cultivation, grazing land, orchards, and buildings for dairy stock, mules, horses, hogs, ducks, turkeys, and chickens. An average of about 100 inmates is constantly employed at farm works. This photograph was taken in the 1930s.

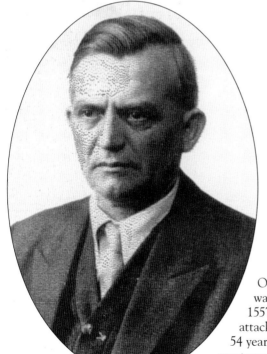

On February 24, 1938, guard Willard G. Johnston was struck in the head with a pick by prisoner 15571, Robert Sterling, and died instantly. The attack was without warning. Guard Johnston was 54 years old. It should be noted that Johnston is the great-great-grandfather of Sgt. Dean M. Handy, who now works at Folsom.

In 1939, the "Tallest Man in the World" astonished the inmates on a tour of Folsom Prison while working for the International Shoe Company. Robert Pershing Wadlow (1918–1940) is still listed in *The Guinness Book of Records* as the tallest man in the world at 8 feet, 11.1 inches tall and weighing 490 pounds. His shoes were size 37 AAA, and his caloric intake was over 8,000 per day. His shoes at that time cost him over $100 a pair. He toured with Ringling Brothers Circus during 1936 and then with the International Shoe Company. His size was due to a tumor within his pituitary gland; he died at 22 years old. This photograph was taken in front of the Officers and Guards Building at Folsom.

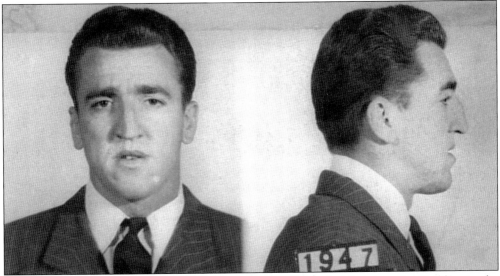

In the early 1940s, inmate Caryl Chessman worked in Folsom's Administrative Building in the records department as a file clerk. He was 27 years old when he was paroled from Folsom. In January 1948, he was arrested and dubbed the "Red Light Bandit" because he would go to various lovers' lanes in Los Angeles and approach young couples with a red light. He then would rob them at gunpoint, and on two occasions, he forced the women in his vehicle to perform sex acts with him. Even though he did not kill anyone, he was found guilty and sentenced to be executed. The charge of kidnapping with bodily harm with intent to commit robbery was a capital offense in California. While on death row, he wrote several books; the first was *Cell 2455 Death Row*, the second *Trial By Ordeal*, and the last *The Face of Justice*. He was put to death on May 2, 1960, at San Quentin.

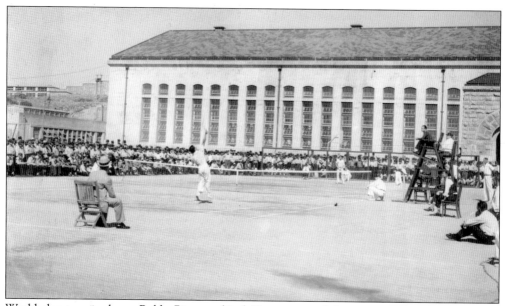

World-class tennis players Bobby Riggs and Jack Kramer visited the prison on October 3, 1940, as guests of warden Plummer. They put on an exhibition of their tennis skills on a temporary court constructed on the main yard. Taking on all comers playing left-handed, Riggs had no problem defeating the inmate tennis players who tried to beat him. This photograph was taken on the main yard during a tennis match with Eddie Alloo (left) and Bobby Riggs (right) on October 11, 1939.

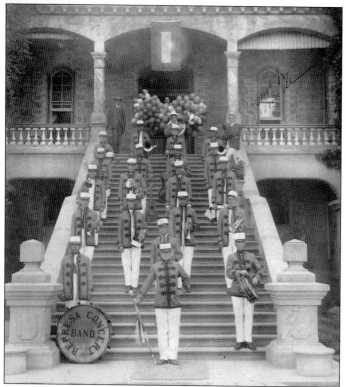

On October 11, 1940, the warden authorized the inmate orchestra to be allowed out of the prison to play at Larkin Hall for employee dances. The prison orchestra was permitted to play during the meals in the dining rooms while the prisoners dined. This photograph was taken on the steps of the Officers and Guards Building in the 1930s.

The Folsom music class is shown here in 1950 practicing under music instructor Art Haring in the Building Two band room (now Unit II's Captain's Office). This jolly place had previously been the site of the second Death House.

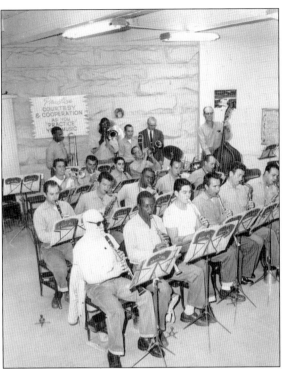

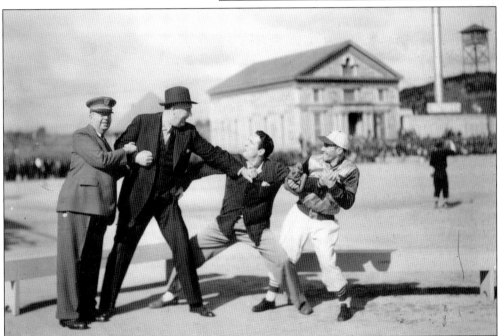

This photograph was taken on the main yard on February 2, 1941, while an exhibition baseball game was being played by minor-league teams. From left to right in this staged fight are Capt. Bill Ryan; heavyweight champion from 1915 to 1919 Jess Willard; heavyweight champion from 1934 to 1935 Max Baer; and Tony Freitas, baseball's winningest left-hander in minor-league history. Freitas had 342 career victories, mostly for the Sacramento Solons of the Pacific Coast League.

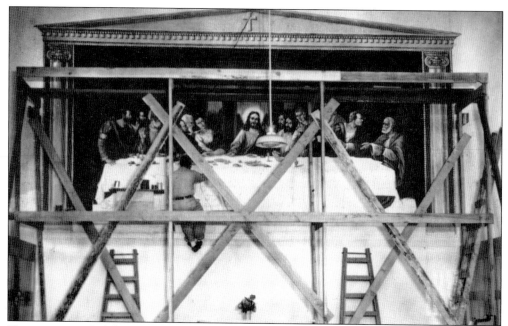

Here is inmate Ralph Pecor painting a version of Leonardo da Vinci's *The Last Supper* in the 1930s. The painting was done right on the back wall during renovation of the Greystone Chapel shortly before the outbreak of World War II.

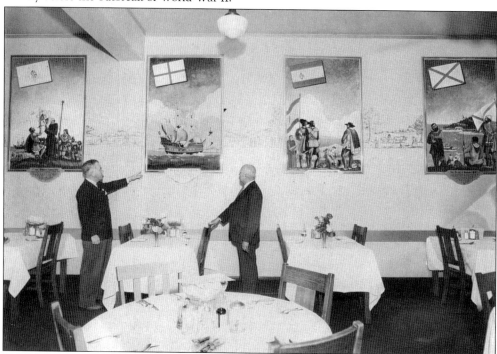

Pecor left a reminder of California heritage in the form of 12 murals painted on the walls of the former Officer's Dining Room, as seen in this 1930s photograph. The captions for these are written in inmate slang but are accurate descriptions of the historical events depicted. Pictured here are Roy Taylor (left), secretary to the warden, and J. J. Lamb, the dining room steward.

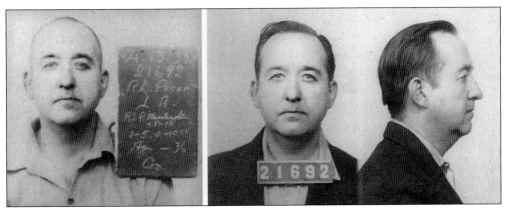

In 1941, Pecor left his legacy and was paroled from Folsom. Not long afterward, he was arrested and sentenced to New Mexico State Prison for a life term as a habitual criminal. While in prison, the doctors discovered he had cancer, and Gov. John Simms of New Mexico released him to die a free man. He died in Santa Fe, New Mexico.

Each cell block had old hand-crank phonographs, which played music until 9:30 p.m. each night. In 1942, the Folsom Prison radio station, KFOL, started with four inmate DJs who ran the radio station under the prison athletic director. The radio station was located next to the telephone room in the basement of the hospital, which is now the Control Room. The KFOL sign hung over the door in the hallway leading out of the Radio Room.

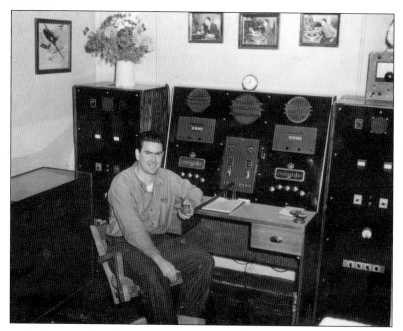

The inmate DJs would play music all day and night long so the prisoners could listen to music in every cell with the aid of earphones. There were two different channels, and a weekly program was printed and distributed to all inmates for their listening pleasure. This photograph was taken in January 1954.

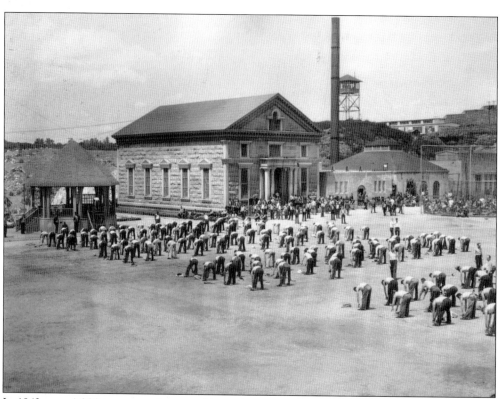

In 1942, over 1,000 inmates volunteered for military training on the main yard, where they wore arm bands with different rank insignias on them in case they were needed during war times.

On January 10, 1944, Governor Earl Warren appointed Robert A. Heinze as warden of Folsom Prison.

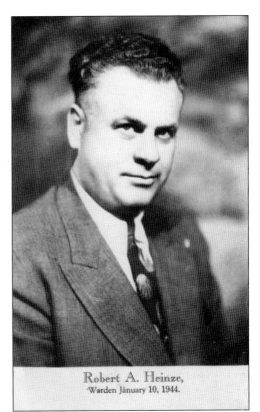

Robert A. Heinze,
Warden January 10, 1944.

The U. S. Navy at Mare Island received many cargo nets on December 5, 1942, that had been manufactured by the prisoners of Folsom Prison. The navy was very pleased with the excellence of the workmanship and looked forward to receiving more to aid in the war effort. There were 80 inmates involved in this project. This photograph was taken on April 14, 1945.

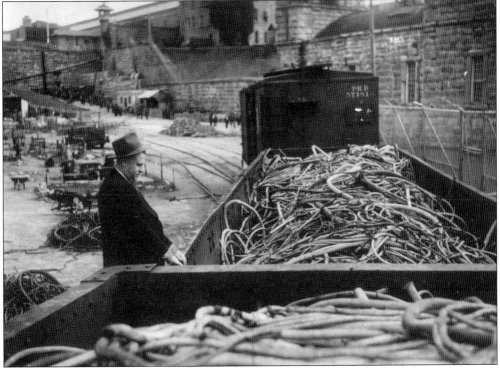

This image shows warden Robert Heinze in the 1940s at a desk made in 1933 in the furniture factory at San Quentin. It was made of walnut, with solid birch drawers, and was approximately 5 feet wide and 6 feet long. It was a double desk, with drawers on both sides. The warden sat on one side, and his male secretary/assistant sat on the other side.

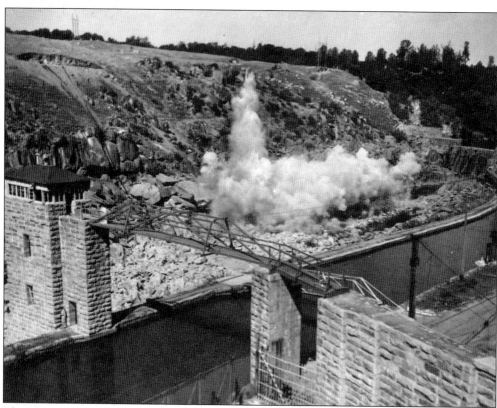

This photograph, taken in the late 1940s, shows the blasting of the riverbed to make it deeper. The blasting is between Tower Five and the old prison dam. Notice that the canal still has water in it.

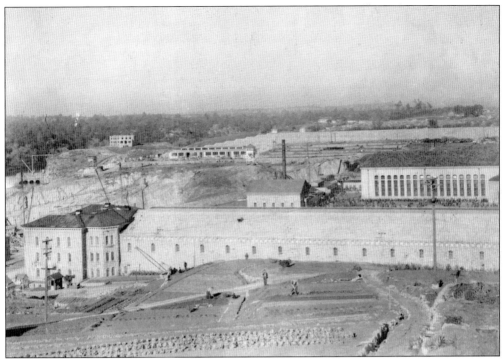

This late-1940s photograph, taken from the top of China Hill looking north, shows prisoners working the terraced section of ground to grow produce for the prison. The Bug House can be seen at center left. Below the Bug House is the Officers and Guards Building, the original Administrative Building. Building Five extends from the Officers and Guards Building to the far right. At dead center is the Greystone Chapel with the smokestack behind the roof. Building One is located above the roofline of Building Five and to the right.

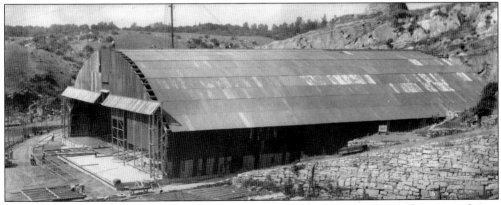

In 1947, the Correctional Industries became operational. Renamed the Prison Industries Authority in 1983, it employs inmates to work with representatives of private industry and labor. This photograph shows the 1940s construction on the B-29 hangar initially used for the program.

Since 1947, all of California's license plates have been manufactured by the inmates at Folsom State Prison. Initially the factory was located in a surplus B-29 airplane hangar in the lower yard.

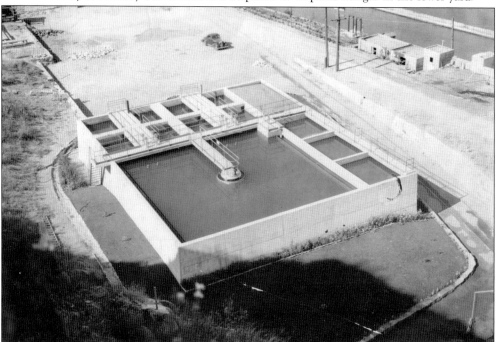

This late-1940s photograph is of the Water Filtration Plant, located near Tower Five along the American River. Notice the canal along the river. The plant supplies clean drinking water to the prison. In many ways, Folsom Prison has always been remarkably self-sufficient.

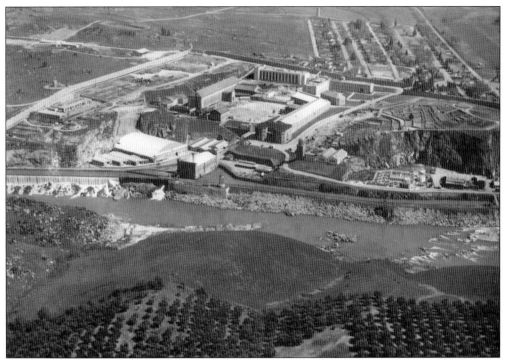

The Ranch Dorm was opened in 1950 with 150 beds for minimum-custody inmates. It is located to the top left sitting all by itself near the prison wall. The upper yard license plate factory has not yet been built, indicating this photograph was taken before 1954. The powerhouse is still being used, and it appears construction for Building Four is under way.

During the 1950s, the CDC (California Department of Corrections) Transportation Division was created, which had three buses that were maintained at Folsom Prison. Prisoners were transported from one prison to another by the buses. This photograph was taken at Folsom Prison on the prison road as staff prepare for an inspection. Notice some staff placing handcuffs and leg irons on the others.

Custody staff are seen here fulfilling their in-service training in the different techniques of the Red Cross First Aid course. This photograph was taken inside Larkin Hall during the 1950s; notice warden Larkin's picture hanging over the fireplace. This building is still used as the In-Service Training (IST) Building today.

FOLSOM STORY WARDEN. . . . The big man standing in the entrance gate to the old building is portraying a Warden, the composite of all the tough Wardens of the old days. But Ted de Corsia out-toughs the toughest of them, sending shudders thru some of the old timers by his realistic acting, the ultimate accolade to an artist. Observer Photo

The movie *Inside the Walls of Folsom Prison* was filmed at Folsom Prison by Warner Brothers in 1950. The original start date of filming may have been on October 10, 1950, with Ted de Corsia playing the role of Warden Rickey.

The prison barbershop was located in the area where the weight pile, or as the prisoners called it "Muscle Ally," had been next to the Athletic Shack on the main yard. Prisoners wishing to learn to be a barber could do so under an apprentice program from skilled barbers now serving time at the prison, all under the supervision of a staff member. Staff had their own barbershop with trained inmate barbers to cut hair and give the old straight-edge razor shave with a hot towel on the face. This photograph was taken in the 1950s.

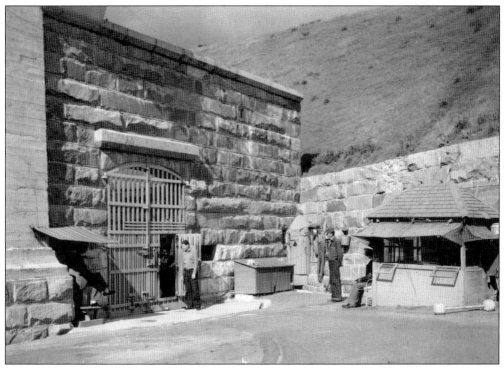

This is the Back Gate, which allowed prisoners to exit the main yard and walk up steps to the Upper Yard of Industries for work assignments. The building to the left is the northeast corner of Building One; above the gate on the corner of the building was a gun tower. Notice the prisoner talking to the officer at the open gate; another prisoner is sitting at the corner of the building and another standing to the right with an officer sitting next to the Back Gate shack. This photograph was taken in the 1950s.

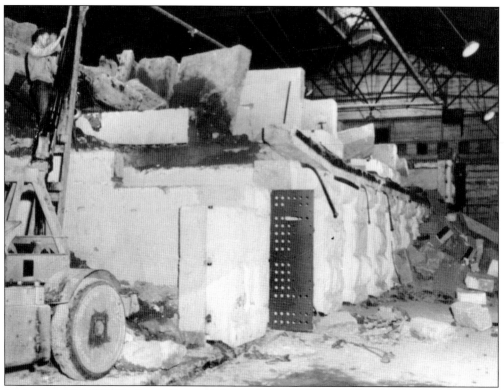

In the year 1951, "C" Block was dismantled to make room for a new dining room, now known as Dining Room Two. This dining room feeds Buildings Two, Three, Five, and some inmates from Four who are general population inmates.

In 1953, the entire Tag Plant operation was dismantled and relocated by Correctional Industries Staff, institutional maintenance staff, and inmates and was reassembled in the new factory located in the upper yard. All license plates for California are manufactured by Folsom Prison. This photograph was taken in June 1962 after it had snowed.

The license plate factory produces an average of 5.5 million plates annually. Although the only customer the prison currently has is the State of California, the prison has the capacity to do much more. Production currently has a workforce of approximately 130 inmates, with a full-service tool and die machine shop.

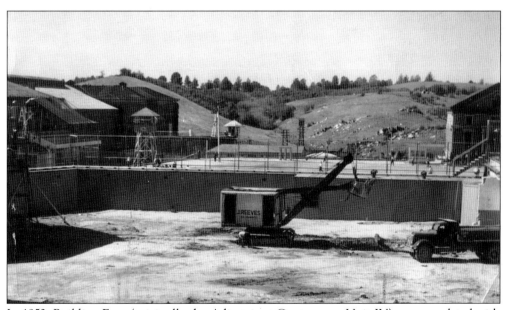

In 1953, Building Four (originally the Adjustment Center, now Unit IV) was completed with 138 management control cells. It was considered "the jail within the prison" for the really bad prisoners. It received its first inmates on January of that year.

The movie *Riot in Cell Block 11* was filmed at the prison by Republic Pictures in 1953, starring Neville Brand and Emile Meyer. This photograph is in front of the gate leading into Building Five. The actor on the right is Neville Brand receiving instructions from director Don Siegel.

The Mexican Mafia (EME) prison gang was formed at the Deuel Vocational Institution (DVI) in 1957 and became known as "the gang of gangs." The mafia was not formed at Folsom but had a large part to do with Folsom's violence over the years. The first name was La Mafia Mexican, which was changed to the present name of Mexican Mafia. "EME" is the pronunciation for the letter "M" in the Spanish language. They are organized along ethnic lines, dealing both within and outside of the prison system in narcotics, murder, and extortion. EME has adopted the insignia of an eagle with a snake in its grasping claw or beak (as seen on the Mexican flag). Members will wear the tattoo of the letters "EME" and the "Black Hand" on different parts of their bodies.

C. W. Parker started work at Folsom Prison as a correctional officer on May 4, 1959, after retiring from the U.S. Navy as a chief warrant officer with over 20 years of service. Three years and five months of this were spent as a prisoner of war in Japan working in the mines. On May 1, 1962, he was promoted to correctional sergeant. Whether convict or staff, if someone needed a helping hand, he was the first to give it. Convicts quickly learned that if they treated Sergeant Parker like a man, he treated them like a man. He taught a lot of staff and convicts how to act and behave and was an excellent role model as a man and correctional sergeant.

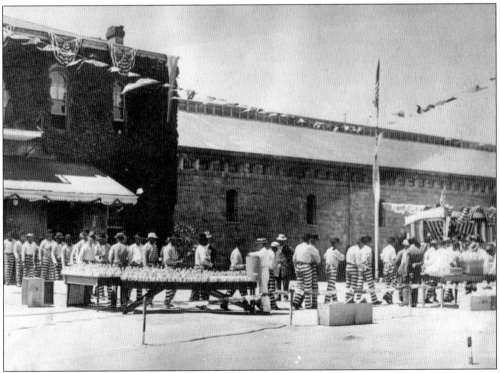

Festive activities are not unknown to Folsom's prisoners. On July 4, 1959, the prison held contests with cash prizes for the first time with $2 handed out to the winners and $1 for the runners-up. Free lemonade was given to all inmates out on the yard. A volleyball league for the inmates was started in the early days by coach Lloyd Kelly. This photograph shows inmates at a celebration in 1910.

The Aryan Brotherhood (AB) prison gang was formed as a "white supremacy" group whose purpose was to protect white inmates from other racially oriented gangs. In the 1950s, this gang was formed as the Diamond Tooth Gang at San Quentin Prison; they attached pieces of cut glass or diamond-like stones to their front teeth. The AB has been responsible for much of Folsom Prison's violence throughout the years. The name later changed to the Blue Birds, as members would tattoo a blue bird on their neck, upper torso, or arms. The emblem was not thought to be masculine enough, so members changed the name again during the 1960s. They can be identified by the tattoo of the letters "AB" or a combination of the letters "AB" with a shamrock. Occasionally the numbers "666" will accompany the "AB." The 666 is the sign that refers to the mark of the beast from the Bible in the Book of Revelation. This photograph of an inmate with the "AB" and shamrock was taken in 1986.

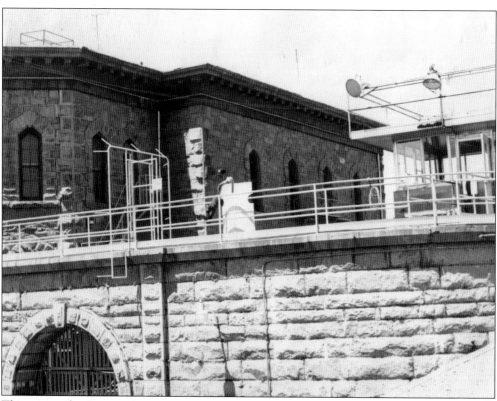

The present-day Tower Fifteen was constructed on the wall overlooking the West Gate and main yard in 1960. Notice the officer standing behind the heavy steel shooting shield in this 1970s-era photograph. Officers carry a pistol and rifle when out on the walkway of the tower.

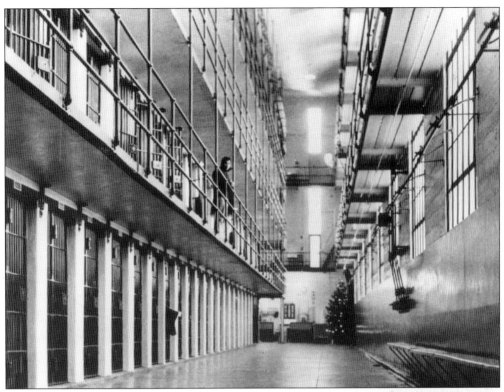

This photograph was taken from the hospital door looking west toward the Building Two sergeant's desk area in 1961. To the right is the building's Christmas tree decorated with lights and ornaments. At Christmas, each building decorates a tree and competes to see which building will win the honor of having the best tree at Folsom Prison. This building is five tiers (floors) high, and to the right is the gun walk, which goes around the building so an armed officer can cover any staff in the building at all times.

The movie *Reprieve* was filmed at Folsom in 1962. Later the name was changed to *Convicts Four*. Starring Broderick Crawford (left), Ben Gazzara, Stuart Whitman (right), Sammy Davis Jr., Vincent Price, Ray Walston, Rod Steiger, and Jack Kruschen, it was filmed by Allied Artists Productions and adapted from the autobiography of John Resko called *Reprieve*.

Sammy Davis Jr. is seen here on stage in November 1961 entertaining out in the main yard in front of the old Receiving and Release Complex (now the inmate canteen). Sammy and Folsom Prison sergeant Jack Brundage reminisced at this appearance about old times when Sammy was a child star; Brundage had been on the same theater poster as Davis many years early as an entertainer.

On March 4, 1966, director of corrections Walter Dunbar recommended Arthur Oliver for the job of warden.

Three

MODERN TIMES

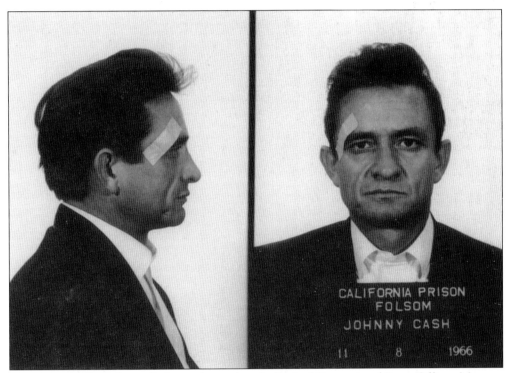

CALIFORNIA PRISON
FOLSOM

JOHNNY CASH

11 8 1966

This "mug shot" of Johnny Cash was donated to the Retired Correctional Peace Officers Museum at Folsom Prison on September 6, 2007, by Jonathan Holiff, whose father, Saul Holiff, was Johnny Cash's manager between 1960 and 1973. Most people know Johnny Cash recorded the seminal live album *Johnny Cash at Folsom Prison* on January 13, 1968, but few know he performed his first concert here in 1966. This photograph was taken in the Receiving and Release Complex at Folsom State Prison on November 8, 1966. The only way to tell it is not the real thing is that there is no prisoner number on the board. Clearly meant to be a joke (though Cash had been arraigned on drug possession charges only 10 months earlier in El Paso, Texas), it is speculated the bandage on Cash's forehead was designed to make it appear that Johnny had been beat up by the staff. Johnny Cash never served time in state or federal prison, but he did spend time in county jail on several occasions. Cash's first prison concert was held at Huntsville Texas State Prison in 1956. During his long career, he performed for inmates at many prisons nationwide and even performed at Osteraker Prison in Sweden.

The Nuestra Familia (NF) was formed in 1957 as a protective counter force against the Mexican Mafia. The first members were Hispanic inmates from the rural areas of the central valley and northern region of California. Because of their rural backgrounds, they were called "farmers." They can be identified by the tattoo of "NF" and an image of a Mexican sombrero with a machete or knife blade through it. The NF will usually have the number "14" and Roman numeral "XIV." Notice the "F" on the gun holster, which represents Familia.

This toaster was made by a prisoner out of a cardboard box with holes punched around the sides. Thin-stripped wire is crisscrossed to make the heating element and is attached to an insulated electrical cord with plug. When electricity flows through the thin wires, they glow hot enough to brown bread, one side at a time. Though ingenious, it is obviously a dangerous device; this toaster was confiscated in 1962.

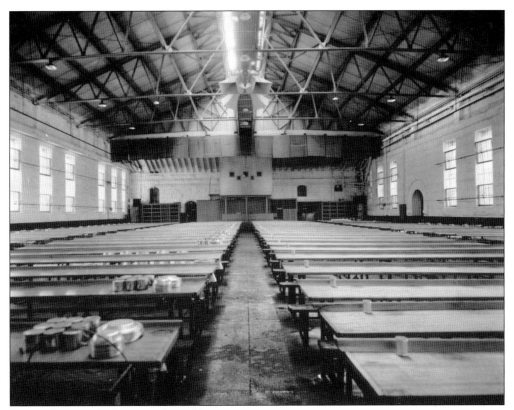

In March 1967, the long wooden tables in the dining rooms were replaced with small wooden ones with four seats at each. This photograph was taken in the late 1960s.

Flyers were posted around the prison telling of the concert on January 13, 1968, staring Johnny Cash. Also performing with Cash were June Carter, the Statler Brothers, and Carl Perkins and the Tennessee Three (Marshall Grant, Luther Perkins, and W. S. Holland).

**FOLSOM STATE
PRISON
ATTENTION
ALL INMATES
IN GOOD STANDING
CONCERT
JOHNNY CASH
JANUARY 13, 1968
INCREASED
SECURITY**

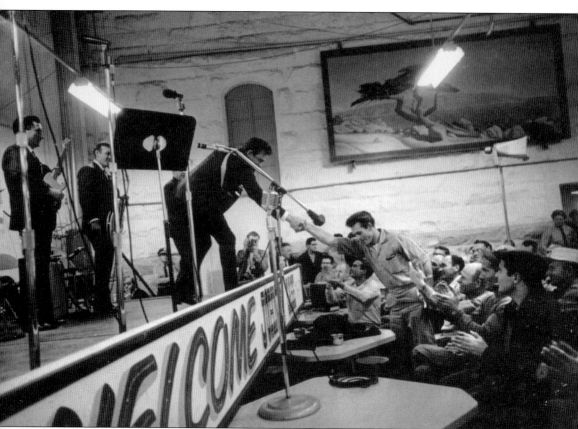

Johnny Cash introduced Glen Sherley on January 13, 1968, as the inmate who wrote the song "Greystone Chapel." Sherley wrote about the structure affectionately known as the Greystone Chapel (see page 98) and how it helped him through difficult times. After shaking hands with Sherley, Cash remarked, "I hope I do your song justice, friend." (Photograph by Jim Marshall.)

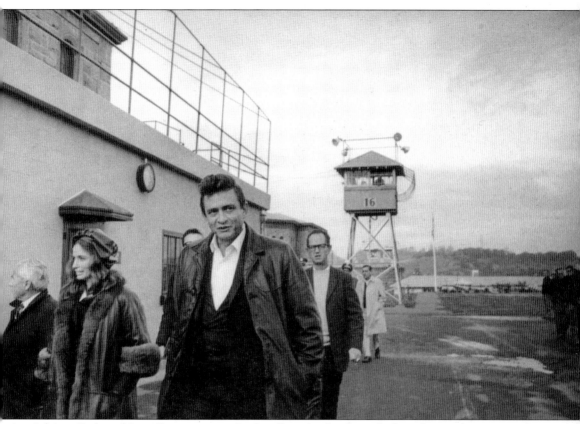

Johnny Cash and June Carter are seen here walking by the Custody Complex on the main yard of Folsom before the January 13, 1968, concert. (Photograph by Jim Marshall.)

This image from the prison newspaper of February 1968 shows Glen Sherley with guitar in hand practicing his music in Folsom's Greystone Chapel.

Gov. Ronald Reagan appointed Walter E. Craven warden on July 5, 1967. Craven became the 14th warden and the youngest to hold the job at the age of 39.

The Black Guerrilla Family (BGF) prison gang was formed in the late 1960s to early 1970s and was comprised of militant, revolutionary black inmates. Originally known as the Black Family, they changed to the BGF in the early 1970s and were supportive of the black movement on the streets. This gang was not formed at Folsom but was responsible for a lot of the violence at the prison over the years. The organization structures itself to a military style of ranking for the membership. They usually display the letters "BGF" as a tattoo and frequently use the symbol of the dragon entwined around a guard tower. The BGF has been one of the most violent of all the prison gangs in California. They have killed more correctional staff than any other prison gang. This is a confiscated gang drawing of the dragon destroying a prison tower with the Swahili words for "Black Guerrilla Family."

On January 1, 1969, the new visiting room was completed, which now is the Receiving and Release Complex. Folsom's Visiting Room had a total 54,302 people visit inmates in 1979 compared to 50,476 in 1978. This photograph was taken in 1971.

The Texas Syndicate (TS) is comprised of inmates committed to California Department of Corrections who had come from the state of Texas. At one time, the TS was large in size in the California System; however, over the years, their numbers have gone down. The TS were noted for attacking anyone at anytime no matter who was around. If it meant they could get shot by staff, they did not care; this put fear in the other gangs. The TS could be identified by the large tattoo of "TS" on the back of their forearms.

In the early 1970s, Ralph "Sonny" Barger (center), prison number A-47342, arrived at Folsom State Prison. He was the leader of the Hell's Angels Motorcycle Club.

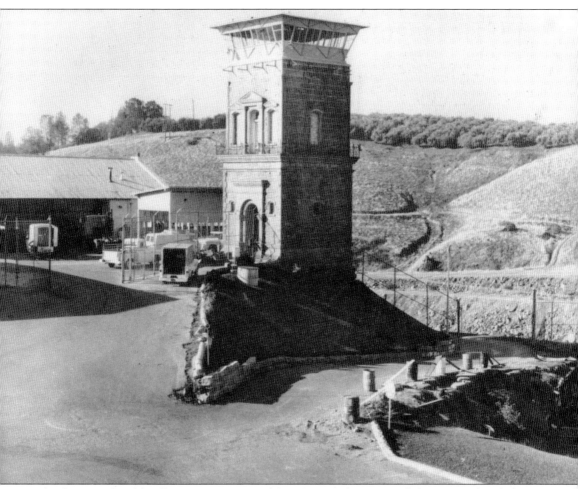

The dome on the old Bell Tower was removed from Tower Thirteen, and the new steel-and-glass tower was constructed with the new "air-traffic control" look and completed on May 11, 1969. In this 1976 photograph, the building to the left is the prison garage. The road going down to the right leads to the lower yard.

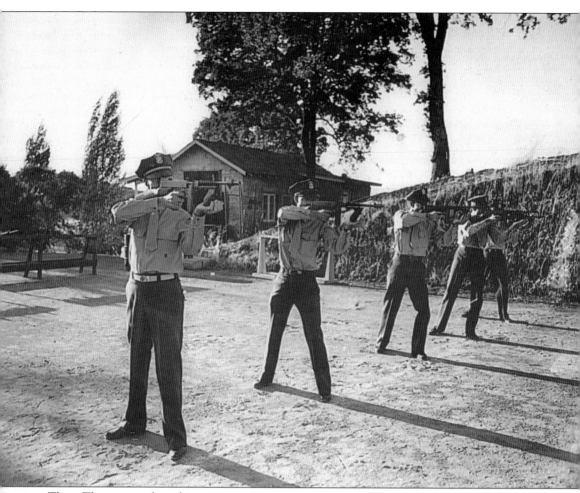

These Thompson submachine guns, or "tommy guns," were light, air-cooled, automatic firearms that could be carried by an officer. They were never used at Folsom except for range practice. This photograph was taken at the range next to Larkin Hall in the 1960s.

This photograph was taken in May 1, 1970, with a line of visitors waiting to get in the Folsom Prison Art Show. Warden Craven is shown leaning against a pole by the small table. The 13th Annual Spring Art Show kicked off with big crowds of visitors from all over the country there to view some of CDC's best inmate artists. Over 6,000 visitors viewed this show. For many years, the Folsom Prison visitor's center sold inmate artwork.

On October 28, 1971, Fr. Denis Keaney transferred to Folsom Prison to become chaplain. He was also counselor, advisor, and friend to both staff and inmates. The inmates here referred to him as the "Pope of Folsom."

Chaplain Denis Keaney
1934 - 2001

A prisoner once said, "Father Keaney doesn't take any guff from anyone." On a tour of the "lockup unit," Keaney was talking to Charlie Manson, who tried to reach through the bars and grab his arm and hand. Father Keaney grabbed Charlie's hand, twisted it against the cell bars and told him, "Charlie, you ever do that again, I'll pull you through these bars and then beat you within an inch of your life."

After Father Keaney started work at Folsom, inmate Mike Ison (number A-66534), a member of the Mexican Mafia, was standing over an inmate he had just stabbed to death in the Greystone Chapel. Father Keaney walked in on him and said, "You're in the House of the Lord!" Ison replied, "The Lord won't have to come far to get this one, then." Ison was paroled from Pelican Bay State Prison (PBSP) in 1994 and on March 25, 2001, was chased down the street and beaten to death with a pool cue at the intersection of Sixth and Mission Streets in San Francisco.

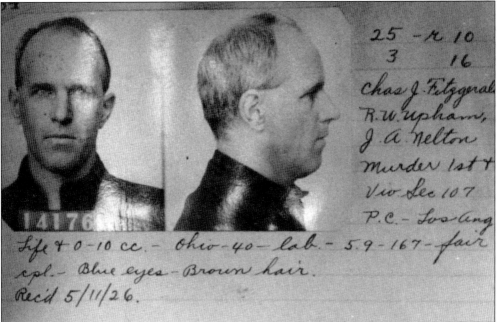

In 1971, Charles "Old Fitz" Fitzgerald (number 14176) was paroled to Sacramento; he was the longest serving inmate in the state of California, serving 45 years for killing two officers. He first went to prison in 1908 for burglary at the age of 22 and served three years. Fitzgerald then killed a Montana deputy sheriff and was sentenced to 100 years, but after 11 years, he was again released because he had "reformed." In 1926, he murdered a San Gabriel police officer during an illegal rum-running operation and was sent to Folsom. Because "Old Fitz" was a nice 85-year-old man, some felt he should be free to finish his remaining years. On October 30, 1976, at the age of 90, he died from a stroke. It is too bad the two officers never got the chance to grow old; how quickly the victims and their families are forgotten.

CALIFORNIA PRISON
FOLSOM
R L TURNER
12 22 69

Ronald Turner was stabbed while working as a laundry supervisor on September 16, 1971. He was found on the floor with inmate Jeffrey Gaulden (number B-09053) standing over him with knife in hand. Gaulden was a member of the Black Guerrilla Family and had killed Turner in retaliation for George Jackson's 1971 death during an attempted escape. Turner, who had worked at the prison for approximately two years, was married and the father of four children. He was 30 years old.

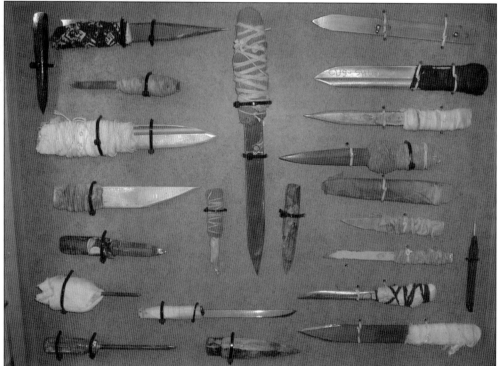

Folsom Prison inmates are occasionally placed on lockdown, per orders of the warden, and a search is conducted by staff of the whole prison. During one such lockdown from September 16 to 23, 1971, over 80 improvised stabbing weapons were found, along with other contraband. This photograph shows some of the weapons confiscated from that search. While in lockdown, inmates were fed paper-sack meals in their cells.

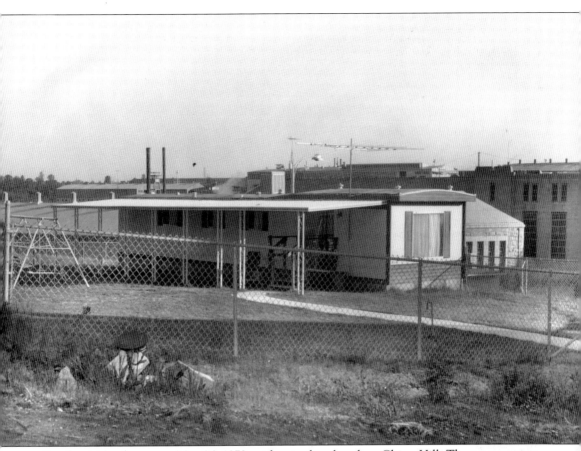

Family visiting began on May 26, 1972, with a trailer placed on China Hill. The program was started so families could come and spend 48 hours together inside the prison. This visiting area is separated from the rest of the prison, giving them a little privacy. The new family visiting units were opened across from Tower Two in 1973. The wives and children of prison inmates are sometimes called "the forgotten victims" of crime.

On June 1, 1973, Jacob B. Gunn was appointed warden, having risen through the ranks during his 23-year career in corrections.

In 1974, the prison newspaper reported, "The Flea Doesn't Walk!" The story read, "Virgil Raymond Teed, better known as the 'Flea' at Folsom State Prison, appeared before the Adult Authority recently, and was denied parole and submitted for program development with the Department of Health. The Flea has now spent close to 28 years in prison since his arrest in 1946. After two years of legal battle in the superior court, the Flea was convicted of first degree murder and sentenced to natural life. Subsequently, the Flea was transferred to Folsom around 1950. From that year on he was transferred back and forth from one California prison to the other, but like a predestination, he kept bouncing back to Folsom where he met most of his rehabilitation. When the Flea arrived at San Quentin in 1948, he had a third grade education. But with a little patience and determination, he was eventually graduated from the fifth grade on November 14, 1958. A lengthy time to advance two years in school perhaps, but who dares to say that this is not the proper road to rehabilitation. The question remains: Who is qualified to make those determinations?"

THE FLEA

This identification card, issued to inmate Virgil "Flea" Teed, has his photograph (taken at San Quentin), prison number, and name on the front. This card must be carried at all times by inmates once they exit their cells. Teed's nickname came from his incredibly poor hygiene; he had said that if he kept himself so dirty, he would never have to worry about someone wanting to rape him in prison.

Gov. Jerry Brown appointed Paul J. Morris warden on September 1, 1976. Morris had started his career in 1951 at San Quentin State Prison.

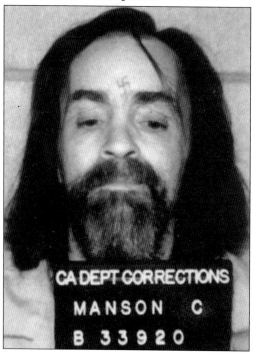

In 1975, inmate Charlie Manson had gone out to exercise on the Building Four yard. He was met by Kenny Como, a white supremacy inmate, in a fistfight. Manson did not throw a punch but did try to block the punches thrown at him. He was knocked down but would get back on his feet each time. Staff had to go out on the yard and stop the fight. It should be mentioned that the AB gang members were sent nude photographs, money, and letters from the Manson girls as part of a protection plan for Charlie. Apparently someone forgot to tell Como about that. Manson's fingers were stained a yellowish brown from smoking cigarettes without filters—the general opinion was that he was a nasty little creep.

Danny Trejo (number A-86986) served time at Folsom Prison during the 1970s for drug and robbery convictions. Danny was paroled from prison and has since turned his life around dramatically, becoming a character actor in the movies. Danny has appeared in the movies *Con Air*, *Heat*, *Reindeer Games*, *Spy Kids*, *From Dusk Til Dawn*, and *Grindhouse*, just to name a few.

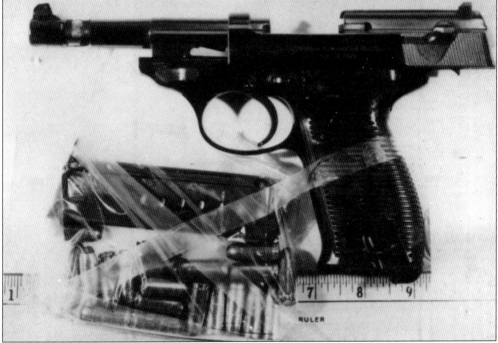

On June 4, 1977, prison officials received a tip that several unidentified inmates had formulated plans to take control of Building One. The note stated that all of the guards would be killed the following Sunday. The writer of the note admitted his involvement in the conspiracy and stated that the massacre was to be accomplished with the use of a Walther P-38 9-millimeter pistol and approximately two dozen rounds of hollow-point ammunition. The note stated that the gun and ammunition were concealed in cell No. 592 on the second tier of Building One. This cell housed Bobby Augustus Davis (number B-31155), who was serving a life sentence for the slaying of four California highway patrolmen in 1970.

The television movie *The Jericho Mile* was filmed at Folsom Prison on October 1978 and aired nationally in March 1979. Peter Strauss received an Emmy for his starring role. The warden talked them into filming the entire movie at the prison; this photograph appeared in the *Folsom Observer* inmate paper in October 1978.

Peter Strauss as Larry "Rain" Murphy, star of The Jericho Mile.

The film company was responsible for placing the jogging track in the main yard. Before this track, the only place an inmate could jog or run at Folsom was around the baseline of the baseball infield. In this photograph, the jogging track is at center right, and the smokestacks at right are from the boiler room, which supplied steam for hot water. The rooftop to the left is the laundry room, and to the right is the clothing room, with the chapel next to it. Building One is at the center far left, Building Four is at the far end of the track, and Buildings Three and Two can be seen over the top of Four. Building Five and the Custody Complex can be seen between the stacks. This photograph was taken in the 1980s.

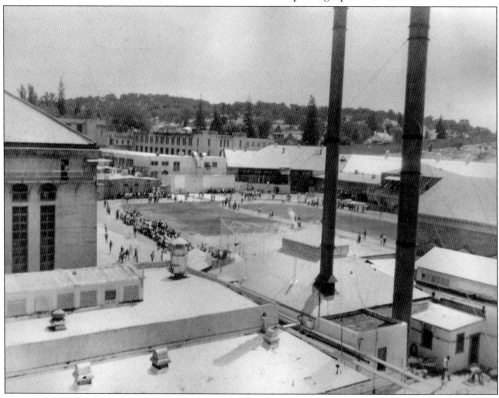

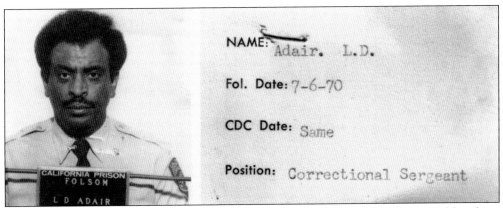

NAME: Adair. L.D.

Fol. Date: 7-6-70

CDC Date: Same

Position: Correctional Sergeant

Correctional sergeant Lewis Donald Adair collapsed and died at 48, responding to a false alarm in the prison hospital on June 5, 1980. Sergeant Adair, known as "Big Lew," was an extremely well-liked, capable, and respected member of the Folsom family. Lew came to Folsom Prison in 1970 after retiring from the U. S. Air Force with over 20 years of service. He is survived by his wife and two sons.

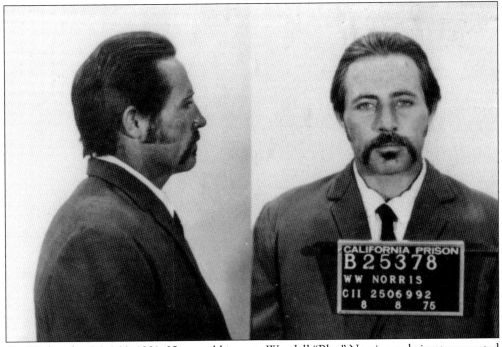

On Wednesday, May 29, 1981, 35-year-old inmate Wendell "Blue" Norris was being transported from Folsom Prison to court when he withdrew a loaded .22-caliber five-shot derringer on Solano County sheriff deputies Patrick Coyle and James Bridewell. Surprisingly Norris had concealed the weapon in his rectum. Norris was a known escape artist, serving a life sentence for a San Francisco murder and robbery. As the patrol vehicle approached the Tennessee Street exit in Vallejo, Norris pulled the derringer and ordered them to drive to San Francisco. He then instructed Deputy Coyle to handcuff himself to the steering wheel and Deputy Bridewell to handcuff himself to Coyle. Both deputies leapt from the moving patrol vehicle at the same time on Interstate 80 just east of the Carquinez Bridge Toll Plaza; they suffered minor scrapes from the incident.

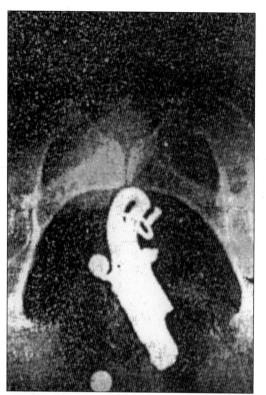

The deputies said Norris had been put through a metal detector, which indicated he had some metal on his person. Norris was strip-searched and a small silver ornament was observed, attached to his genitalia. Staff members were going to remove the silver ornament when the deputies said they weren't concerned about it. Norris was placed in full restraints in the back of the patrol vehicle. A search of his cell at Folsom revealed a hollowed-out book, thought to be the hiding place of the rectum-concealed derringer (shown in this x-ray view from another such incident). Norris received more time for this escape attempt yet some years after the derringer incident did it again. He told staff he had something inside him he could not remove and subsequently had surgery to remove two Prell shampoo bottles taped together. When asked why he had concealed these items in his rectum, Norris matter-of-factly explained that he was trying to stretch his colon in order to get a bigger gun smuggled into the prison so he could kill staff. Together the two bottles were 13 inches long.

This "OUT OF BOUNDS" sign was one of many throughout the prison. They were hung up after feeding release lines, yard in lines, and yard out lines. Once a gate was locked and the sign hung up, anyone wishing to enter a building or go on a tier would need permission from staff before entering.

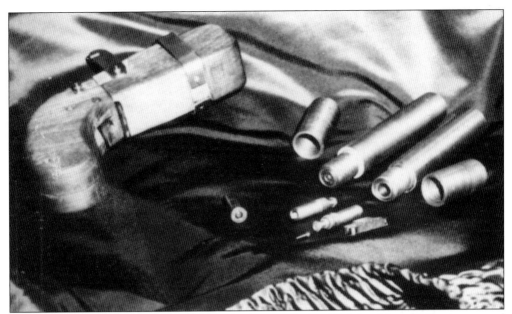

December 12, 1981, while conducting a search of inmate Richard "Mickey Mouse" Miles (connected to the AB gang), correctional officer Vern Lockhart found an inmate-manufactured double-barreled pistol tucked inside the waistband of his pants. The pistol was a large, over and under derringer type having rifling inside both barrels with black walnut handgrips. Both barrels were cocked and loaded with .38-caliber bullets. It was rumored that Miles was to shoot inmate Hugo "Yogi" Pinell (connected to the BGF gang) because he was in trouble with his own gang. The hit was allegedly ordered as a good faith gesture to create a bond between the AB and BGF.

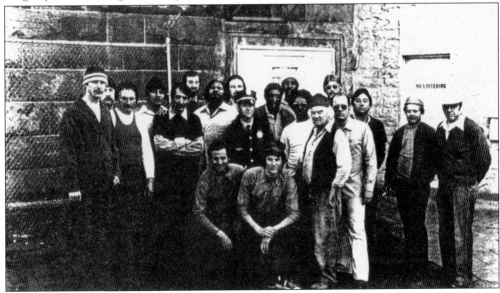

The television movie *The Outlaws* was filmed at Folsom in 1982, starring Dub Taylor, Chris Lemon, and Charles Rocket, along with Folsom staff Art Smith, Red Jordan, Joe Gonzalez, Bob Jimenez, Al Rios, Larry Doom, John O'Neal, Kevin Huttner, Gil Miller, Jim Buster, Lloyd Kennedy, Allen Baber, Jerry Burpo, L. E. Davis, Richard Yamamoto, Richard Wiff, and Art Tomesetti. This photograph was taken in front of Dining Room Two's exit door to the main yard during the filming.

On September 9, 1971, inmates at New York's Attica Prison rioted and took staff hostage. Ultimately, there were 11 dead hostages, 37 hostages injured, 29 dead inmates, and 89 inmates injured. This was the result of law enforcement personnel from around the state firing hundreds of bullets into the prison. In February 1980, a horrifying riot and hostage takeover occurred at the New Mexico State Penitentiary at Santa Fe (a harrowing book called *The Hate Factory* was written about that incident). Based on these takeovers, many recommendations were implemented for improved safety and security in California, leading to an Emergency Operations Program. One of the first teams organized was the Folsom State Prison's Special Emergency Response Team (SERT). Correctional lieutenant Jim Butler (right) commanded the SERT, and his assistant commander was correctional lieutenant Glenn Mueller (left).

Joe Campoy was appointed warden on January 3, 1984. He was hired at Folsom Prison during the postwar period after being discharged from the service in 1946. Campoy worked his way up the ranks as officer, sergeant, lieutenant, counselor, captain, associate warden, chief deputy warden, and then warden.

In October 1985, Gov. George Deukmejian dedicated the new CYA (California Youth Authority) and CDC Peace Officer Monument, which had been constructed on the site of the Correctional Training Center (CTC) at Galt, California. The monument, shown here in the 1996 ceremony, was built by the members of CCPOA's Retired Chapter. They recovered cut granite blocks that had been torn down from the old "Bug House" in 1951 and 1952 at Folsom. Bricks from the Youth Authority at Preston and San Quentin were donated for the monument.

Gone but not forgotten — CRC Correctional Officer Don Baker and his daughter, Tiffany, spend a moment in front of the monument that now bears the name of their loved one killed in the line of duty: wife and mother Ineasie Baker, the YTS youth counselor who was killed Aug. 9, 1996. Her death is still under investigation.

While the Academy cadets stand at attention, Gov. Pete Wilson places the wreath at the base of the memorial monument in honor of the 33 officers killed in the line of duty whose names are on the granite monument. CCPOA Executive Vice President Mike Jimenez (right) looks on. **(Photo courtesy of Ed Anderson)**

The Wreath Laying Ceremony has become an annual tribute to the fallen staff. Plaques contain the names of all employees who were killed in the line of duty. Here Gov. Pete Wilson lays the wreath at the base of the monument in October 1995.

Robert G. Borg became the warden on October 21, 1985. He had worked at the California Men's Colony (CMC), Sierra Conservation Center (SCC), California Medical Facility (CMF), and the California Rehabilitation Center (CRC).

On June 5, 1987, convicted murderer Glen S. Godwin (number C-36864) was able to escape from Folsom Prison by slipping into a storm drain and fleeing along the American River in a small raft. Former inmate Lorenz Karlic had come up the American River in a canoe, close to the east bank out of the River Tower officer's sight. Once past Tower Six, he approached the storm drain, cut through the gate, and proceeded with flashlight and cutting tools, painting smiley faces and arrows showing the way to the river on the granite wall. After several nights, Karlic accomplished this and went underground all the way up to Building Two, halfway inside the prison, cutting the drain grill covering that entrance. He left a flashlight, pistol, and change of clothes for Godwin. With the help of his wife, Shelly, Godwin is still at large. *America's Most Wanted* has done several programs on his escape, without any sightings thus far.

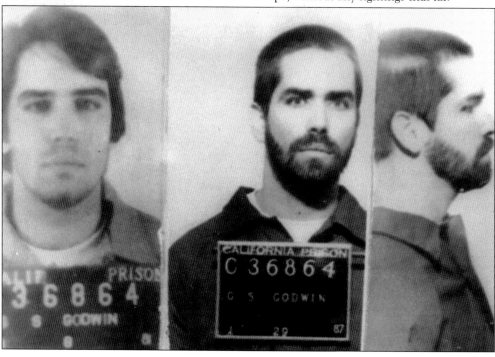

Lake Natoma was created when Nimbus Dam was constructed across the American River. The lake is a regulated reservoir for release of water from Folsom Dam and is managed by the California Department of Parks and Recreation under agreement with the Bureau of Reclamation. The sign was found next to the river on prison property during the search for escapee Glen Godwin on June 6, 1987. It was then donated to the museum.

On July 7, 1987, while being searched in New Folsom's Security Housing Unit (SHU), Paul "Cornfed" Schneider (an AB member) stabbed officer Carl Kropp in the throat. This stabbing was ordered by Art "Ox" Ruffo, an AB member, because Ruffo had been previously shot by officer David Pitts on June 24, 1987, while attempting to stab Red Rag street gang member Adrian Lloyd on the SHU exercise yard. This was part of a conspiracy to assault all staff in "B" SHU. The plan was that all AB brothers were to have weapons and to stab staff as they attempted to extract them out of their cells. Officer Kropp made a full recovery and returned to work. He is now Sergeant Kropp and still working at Folsom Prison. The knife used to stab him is on display in the museum.

In 1988, an Honor Guard formed at Folsom State Prison and New Folsom Prison, now named California State Prison, Sacramento (CSP-SAC); these were once considered the same prison but were separated in 1992. The Honor Guard still consists of members from both prisons, as shown in this July 26, 1990, photograph in front of Larkin Hall.

On October 1, 1992, Folsom State Prison was divided into two separate prisons—"New Folsom" was built in 1986 and named CSP-SAC, with a population of 3,500 inmates. Theo White was named warden at the new prison.

Folsom Prison, with 3,280 inmates at the time, received Teresa Rocha as the new warden in 1992. She was the first female appointed as warden at Folsom Prison. She began her career with CDC in 1982 as a consultant to the Planning and Construction Division. Rocha is pictured here second from the left in the first row.

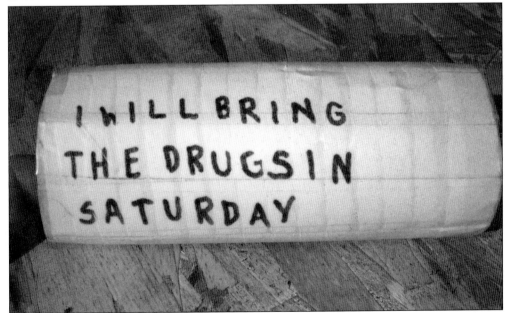

Prisoners use many methods to transmit coded messages involving criminal activity inside the prisons and out to the streets. The Scytale Code, shown here, is a messaging system named for the Latin name of the earliest known code device. To write a coded message, a long strip of paper is wrapped in a spiral around a cylinder such as a cardboard tube. After the strip is wound, the message is written in rows that run the length of the cylinder. When the strip is unwrapped, the letters are scrambled. This method was first used by the Spartans in the fifth century B.C.

On July 1, 1996, Glenn A. Mueller was chosen for the position of warden at Folsom. He began his career as a correctional officer in 1968 at Folsom. Mueller helped implement the "Three Strikes" Law at Folsom and tried to bring the "chain gang" to work on the California highway system.

As the crowd looked on, California dignitaries and family members of CPOs killed in the line of duty officially broke ground on the future site of CCPOA's memorial monument. Left to right, Lt. Gov. Gray Davis, Assemblywoman Helen Thomson, West Sacramento Mayor Wesley Beers, Pechanga Tribal Leader Mark Macarro, Barbara Birchfield, whose husband, San Quentin C.O. Howell Birchfield, was killed in the line of duty in 1985, and Assemblyman Bill Leonard.

This image shows an October 29, 1998, ground-breaking ceremony at the CCPOA headquarters to start construction on a new memorial to honor officers from the CYA and CDC. The memorial was designed by the retired chapter of CCPOA. The 20-foot black marble wall rests on a granite base. There is a statue of a correctional peace officer in dress uniform, blowing "Taps" on a bugle for those fallen heroes. Lt. Gov. Gray Davis was a guest speaker at this ground-breaking ceremony.

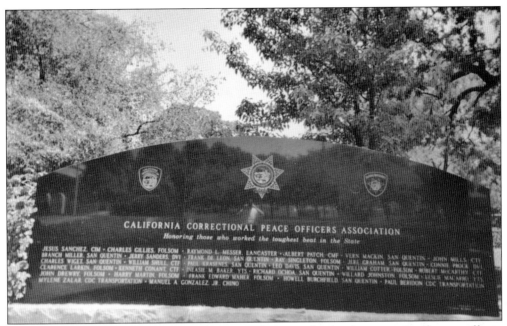

For those who gave their all, CCPOA has created a remembrance for correctional peace officers who died in the line of duty, albeit with a little controversy. The original monument had been built by CCPOA's Retired Chapter, at the Galt Academy on state property, and the Department of Corrections decided they would take over the annual memorial service, essentially telling the Retired Chapter to butt out. The Retired Chapter suggested that if they could raise the money, they too would like build a new memorial at the CCPOA headquarters.

On May 14, 1999, Karl Malone of the Utah Jazz was in California to play the Sacramento Kings the next day. Malone and his agent were granted a tour of Folsom Prison by the warden.

In December 1999, a proposal for restoring the Folsom Prison Cemetery's wooden headstones was approved by the warden. The wooden grave markers were so worn that they were illegible or just broken and falling apart. Inmate Chester Reed, an experienced stonemason, volunteered to teach inmates Demetris Daniels, Ricky Latchison, Joseph Rodriguez, and Edward Gonzoles how to carve granite. Reed noted that in the old days, inmates often made headstones for the condemned men out of respect. Reed and the others involved in this project saw it as giving something back to the deceased. The granite headstones were cut with a masonry saw, and prison numbers and dates were chiseled into the face by hand. The headstones were then placed in the cemetery, replacing the old wooden ones. Reed is now paroled and back with his wife; this writer thanks him for his help in this selfless pursuit.

Diana K. Butler was appointed warden on July 24, 2001. She was only the second female warden in Folsom's long history.

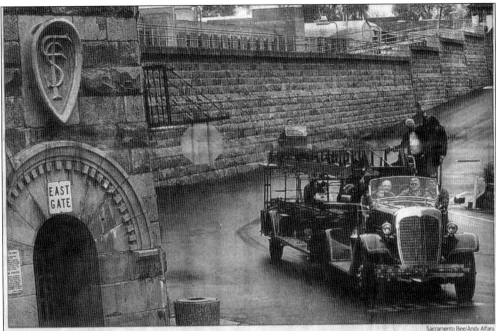

Sacramento Bee/Andy Alfaro

Bernie Quinn, at top, grandson of San Francisco firefighter John Quinn, hangs on as his father's old ladder truck is driven outside Folsom Prison, above. Inmates spent the last four years restoring the custom truck, one of only two in the world. Below, the original red paint and gold leaf is back.

Folsom Prison inmates restore old fire engine

On March 4, 2005, a rare 1939 Ahrens Fox Custom Ladder Fire Truck was "paroled" from Folsom Prison after inmates and vocational education staff worked 18,000 hours restoring it to showroom condition. The truck, originally part of the San Francisco Fire Department fleet, now belongs to the Ahrens Fox Restoration Society in Plymouth, California. It cost $11,000 for all the chrome used in the restoration and $3,000 for lumber to replace the running boards.

The prison's menu has improved over the years—the only difference now is that as the inmate exits the dining room, he receives a sack lunch, as there are no more hot meals served in the dining room at noon. This menu is from April 2005.

WEEKLY MENU

FOLSOM PRISON — CSP-FSP-MSF-RANCH-S.A. AD-SEG
MENU FOR: FOUTH QUARTER WEEK # 3 — *DATE FROM* 04-11-05 TO 04-17-05

DAY	BREAKFAST	LUNCH	DINNER
M O N D A Y	FRESH APPLE	PASTRAMI LUNCHMEAT (T)	COTTAGE CHEESE
	HOT RICE CEREAL (5)	FRESH BREAD (4)	CHICKEN PATTY
	CREAMED BEEF	MUSTARD (2)	HAMBURGER BUN
	TRI-TATERS	COOKIE	MAYONNAISE PACKET (1)
	BISCUIT (1) TOAST (1)	FRESH FRUIT	SEASONED PINK BEANS
	CHILLED MILK	IND. BEVERAGE PKT.	GREEN PEAS
	HOT COFFEE		GELATIN
		AE: PEANUT BUTTER & JELLY	HOT COFFEE
	AE: POTATOES & BISCUIT	APRIL 11, 2005	AE: SEASONED PINK BEANS
T U E S D A Y	FRESH BANANA	SMOKED TURKEY W/CHEESE	GREEN SALAD /DRESSING
	CRACKED WHEAT CEREAL (5)	FRENCH ROLL	CHICKEN ENCHILADAS
	PANCAKES (3)	MUSTARD (2) MAYONNAISE (1)	ENCHILADA SAUCE
	PEANUT BUTTER	FRESH APPLE	SPANISH RICE
	MAPLE SYRUP (2)	COOKIE	PINTO BEANS
	MARGARINE	IND. BEVERAGE PKT.	MEXICORN
	CHILLED MILK		CANNED FRUIT
	HOTCOFFEE		HOT COFFEE
		AE: CHEESE SLICE (3 TOTAL)	AE: RICE & BEANS
		APRIL 12, 2005	
W E D N E S D A Y	FRESH APPLE	SLICED TURKEY	GREEN SALAD / DRESSING
	BRAN FLAKES	FRESH BREAD (4)	CHICKEN STEW
	SCRAMBLED EGGS	MUSTARD (2)	STEAMED RICE
	HASH BROWNS	COOKIE	SEASONED CORN
	TOAST (2)	FRESH FRUIT	BREAD (2)
	MARGARINE	IND. BEVERAGE PKT.	SPICE CAKE W/CANNED FRIUT
	CHILLED MILK		HOT TEA
	HOTCOFFEE	AE: PEANUT BUTTER & JELLY	AE: RICE & VEGETABLES
		APRIL 13, 2005	
T H U R S D A Y	FRESH FRUIT	PEANUT BUTTER	COLESLAW W/DRESSING
	HOT FARINA	JELLY (2)	BREADED FISH / TARTAR SAUCE
	BREAKFAST BURRITO	FRESH BREAD (4)	MACARONI & CHEESE
	PINTO BEANS	COOKIE	GREEN BEANS
	SALSA	FRESH APPLE	WHEAT BREAD (2)
	WHEAT TOAST(2)	IND. BEVERAGE PKT.	APPLESAUCE CAKE
	CHILLED MILK		HOT COFFEE
	HOT COFFEE		
	AE: PINTO BEANS	APRIL 14, 2005	
F R I D A Y	FRESH FRUIT	SMOKED TURKEY	PASTA SALAD
	ROLLED OATS (5)	FRESH BREAD (4)	HAMBURGER W/ BUN
	DANISH	MUSTARD (2)	SLICED TOMATO / CHEESE SLICE
	PEANUT BUTTER	COOKIE	FRIED POTATOES (D)
	TOAST (2)	FRESH FRUIT	SEASONED BROCCOLI
	MARGARINE	IND. BEVERAGE PKT.	MUSTARD (2)
	CHILLED MILK	AE: PEANUTBUTTER & JELLY	POWDERED CAKE
	HOT COFFEE		HOT TEA
		APRIL 15, 2005	AE: PASTA SALAD
S A T U R D A Y	FRESH APPLE	PEANUT BUTTER	FRESH SALAD / DRESSING
	HOT FARINA (5)	JELLY (2)	SPAGHETTI W/MEATSAUCE
	WAFFLES (3)	FRESH BREAD (4)	SEASONED WHITE BEANS
	MAPLE SYRUP (2)	COOKIE	SEASONED SPINACH
	MARGARINE	FRESH APPLE	FRENCH ROLL
	CHILLED MILK	IND. BEVERAGE PKT	FRUIT PIE
	HOT COFFEE		HOT COFFEE
		APRIL 16, 2005	AE: SEASONED WHITE BEANS
S U N D A Y	FRESH BANANA	TURKEY BOLOGNA	FRESH SALAD/ DRESSING
	GRITS	FRESH BREAD (4)	BAKED CHICKEN
	FRIED EGGS (2)	MUSTARD (2)	FETTTUCINE NOODLES /W GRAVY
	OVEN BAKED POTATO WEDGES	COOKIE	CARROTS
	BREAKFAST PATTY (T)	FRESH APPLE	FRESH BREAD (2)
	TOAST (2)	IND. BEVERAGE PKT.	ICE CREAM
	MARGARINE		HOT COFFEE
	CHILLED MILK / HOT COFFEE	AE: PEANUT BUTTER & JELLY	
	AE: POTATOES & TOAST	APRIL 17, 2005	AE: NOODLES & VEGETABLES

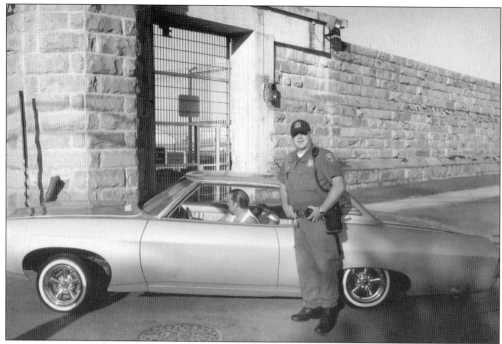

In 2005, Jesse James and the *Monster Garage* crew got stuck in Folsom Prison. The television show challenged Folsom prisoners Eric Schneider, Josue Corral, Falvius Knox, Saul Marquez, and Samuel Padgett to rebuild a 1969 Chevy Impala. The team turned a rusty hulk into a trimmed lowrider dream car with frosty-green, metal-flaked paint and new interior. This photograph was taken after Jesse James (driving) exited the North Gate with officer T. Boone escorting him to a photo shoot in front of the East Gate.

On May 4, 2006, warden Matthew C. Kramer recited the Oath of Allegiance during a ceremony naming him Folsom Prison's warden.

In an artistic expression of what undoubtedly represents an attractive aspect of freedom to many on the inside, inmate Michael Plunkett created *Big Hair-Dirty Girl*, an acrylic oil painting on canvas, during 2004. The motorcycle looks very similar to the one used in the 1969 movie *Easy Rider*, starring Peter Fonda and Dennis Hopper, and the rider resembles Jane Fonda from one of her early movies. The work is one of many such inmate creations on display at the prison museum; this painting was donated by Charlene and Andy Hunt in July 2007.

ACROSS AMERICA, PEOPLE ARE DISCOVERING SOMETHING WONDERFUL. *THEIR HERITAGE.*

Arcadia Publishing is the leading local history publisher in the United States. With more than 4,000 titles in print and hundreds of new titles released every year, Arcadia has extensive specialized experience chronicling the history of communities and celebrating America's hidden stories, bringing to life the people, places, and events from the past. To discover the history of other communities across the nation, please visit:

www.arcadiapublishing.com

Customized search tools allow you to find regional history books about the town where you grew up, the cities where your friends and family live, the town where your parents met, or even that retirement spot you've been dreaming about.